IMAGES
of America

WOODBURY,
ORANGE COUNTY

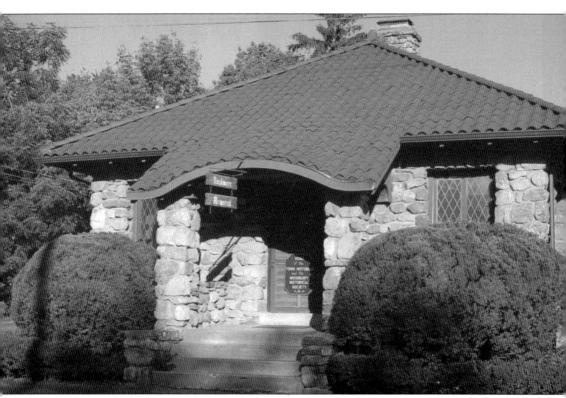

Rushmore Memorial Library was built and donated to Woodbury in 1923 by the family of Charles E. Rushmore, for whom Mount Rushmore was named. The library became home to the Woodbury Historical Society in 1984. It was designated a historic building in 2010 and added to the New York State Register of Historic Places. (Courtesy of the Woodbury Historical Society.)

ON THE COVER: In 1911, the unfortunate driver of this car found himself in the creek under the train trestle near Weygant's Carriage Manufactory in Lower Central Valley. It was retrieved by shopworkers (in no particular order) Fred Brush (painter), Spence Bailey (painter), Eli Bloodgood, McIntosh (harness maker), Mike Sullivan (blacksmith), Fred Jones, Bill Stevens (car washer), Fred Weygant (boss), Henry Burgunder (mechanic), and Tom McMann (horseshoer). (Courtesy of the Woodbury Historical Society.)

Images of America
Woodbury, Orange County

Sheila A. Conroy and Nancy S. Simpson

Copyright © 2014 by Sheila A. Conroy and Nancy S. Simpson
ISBN 978-0-7385-7698-5

Published by Arcadia Publishing
Charleston, South Carolina

Printed in the United States of America

Library of Congress Control Number: 2011943544

For all general information, please contact Arcadia Publishing:
Telephone 843-853-2070
Fax 843-853-0044
E-mail sales@arcadiapublishing.com
For customer service and orders:
Toll-Free 1-888-313-2665

Visit us on the Internet at www.arcadiapublishing.com

To early Woodbury historian Emma McWhorter and fellow original committee members who helped create the Woodbury Historical Society in the 1980s—Margaret Kirk, Roslyn and Murray Duberstein, Isabelle Babcock, and "Bud" Burgunder

Contents

Acknowledgments		6
Introduction		7
1.	Early Days	9
2.	Bring the Servants	17
3.	Boarders Pitch In	33
4.	Central Valley Businesses	41
5.	Highland Mills and Woodbury Falls Businesses	55
6.	Health and Schools	69
7.	Famous People	83
8.	Community Life	93
9.	Farewell to the Horse and Buggy	105
10.	Changes Come to Woodbury	115

Acknowledgments

I would like to give special thanks to Leslie Rose, Woodbury historian, whose assistance immensely supported this endeavor and kept this publication dream alive. Her patience with researching and proofreading, and with many files being disturbed, is deeply appreciated

Special acknowledgement goes to my coauthor, Nancy, whose idea it was that we could write this book together but who passed away before its completion. Her writing gifts are evident in the introductions for chapters 2, 3, 9 and the general introduction as well as for numerous captions. I promised to finish what we had started and hope to have done justice to her vision. I would especially like to thank acquisitions editor Caitrin Cunningham, who was assigned to us shortly before Nancy fell ill. She has gently guided and encouraged the endeavor to complete this journey through many challenges.

Two others deserve special recognition: My husband Patrick jumped in, becoming a sounding board, researcher, and proofreader. Christopher Lotito, a web designer and photographer, generously scanned over 300 images. Without them, the book might have been abandoned.

I cannot adequately express gratitude to our families and friends who never wavered in their belief in our book. Robin Crouse helped through difficult days, delivering meals, doing research, proofreading, and checking in during lonely writing marathons. Author Barbara Gottlock generously shared helpful tips. Jing Cai, Lorraine McNeil, and Marghi and Edward Quigley lent technical assistance. Robert Prosperi of the Computer Depot rushed delivery of a replacement laptop barely ahead of a major snowstorm and the submission deadline.

Others deserve acknowledgment including James Nelson, Monroe town historian; Dorothy Helbing Morris, whose photographs enriched stories about boarders; William Cavanaugh, whose collection filled gaps; and the late David Woodward, whose writings provided vivid details of community life. Appreciation goes to residents who shared reflections that added depth to events and places: Robin Burkhardt, Mary and Robert Cromwell, William Doyle, the Hintze family, Barbara Hunter, Louise and Joseph Kopchak, Donald Nazzaro, Thevenet and Sister Teresita Morse, Ferris Tomer and the Highland Mills Fire Department, Walter Stanfield, Frances Woodward Van Etten, and Janice Walsh.

Unless otherwise noted, all images are courtesy of the Woodbury Historical Society.

INTRODUCTION

Washington Irving wrote his famous story *Rip Van Winkle* about the Hudson Valley and the Catskill Mountains, which are geographically not far from the town of Woodbury. After too much to drink, Van Winkle fell asleep for 20 years, only to awaken to see surprising changes to his surroundings. What would it be like to fall asleep and drift back to a Woodbury of 200 years ago? Is there anything that might seem familiar?

There would be a road of sorts running north and south along the base of Schunnemunk Mountain. Throughout much of its history, this thoroughfare was called Kings Highway, or the New York–Albany Turnpike; today, it is Route 32. If one followed Woodbury Creek where it crosses this road into what is now the business district of Highland Mills and traced the tributary stream to its source, he or she would climb the hill along today's Route 105. A half-hour's walk would lead to Rumsey's Pond, a beautiful spring-fed lake later known as Hazzard's Pond and now called Cromwell Lake. At the time, Woodbury was dotted by lakes, ponds, and creeks, some of which are no longer part of the town, having been appropriated by West Point or absorbed into the Palisades Interstate Park.

What might be most shocking would be the dearth of trees. For decades, the area's iron blast furnaces operated around the clock, consuming acres of deciduous trees to process iron for the Forest of Dean and other local mines. From the area of Queensboro near the Route 6 traffic circle, which was once part of Woodbury, it was said that one could see all the way to the Hudson River, with only stands of evergreens in between.

One would also notice the uncanny quiet, without the traffic of trains, planes, or cars. Farms owned by descendants of original Quaker pioneers were spread like a lumpy patchwork quilt over the hills and the valley. One could walk considerable distances without seeing another person. These farms were self-sustaining places where weather and seasons dictated the rhythm of the days. Many early diaries include daily comments about the weather and its effect on chores.

Except for the natural contours of the land, which have also been changed by man, it would be difficult to orient oneself to the Woodbury of yore. The town did not exist as the separate entity it is today until 1889. It and Southfields were part of Tuxedo, which in turn was part of the large town of Monroe, which had originally been part of Cornwall. State parks, West Point, and protected wetlands and waterways have removed almost 50 percent of 1889 Woodbury from development and the tax rolls.

A monumental change to the valley between the mountains came in 1869 when the Erie Railroad Shortcut disturbed the bucolic serenity of the farmlands. One reason for the stops in Central Valley, Highland Mills, and Woodbury Falls was to transport milk and produce from local farms to New York City quickly and efficiently. This was a boon to an industry that had grown up in the years before the Civil War.

As fresh farm produce began to meet the demands of city folks, trains began to bring some of those city folks back to Woodbury. Visitors needed places to stay, transportation to view the

area's beauty, and recreation to keep them and their dollars in town. A new, profitable industry was born: tourism.

In Central Valley, Highland Mills, and Woodbury Falls, stores were built and expanded to serve these visitors, as well as the local populace. What was called Lower Central Valley grew around the railroad station near the intersection of Main Street (Smith Clove Road) and Academy Avenue (Valley Avenue). For almost four decades, this was the center of the hamlet, the hub around which everything revolved. A portion of the Highland Mills business district would be familiar to today's citizens, arranged along the New York–Albany Turnpike. What might be less familiar were the stores and factories lining Railroad Avenue (Park Avenue) from the turnpike to the railroad station, just beyond the sharp curve over Woodbury Creek, or the businesses along Route 105.

Tourism's boom years lasted until the 1910s, with its demise partially heralded by the automobile. Tourists no longer were confined to the arteries of rails crisscrossing the country on fixed schedules. Motorists could set out for unseen wonders without a timetable. To capture as much of the motoring trade as possible, the hub of Central Valley gradually moved to Upper Central Valley, along Route 32. Lower Central Valley and Railroad Avenue in Highland Mills and Woodbury Falls started their slow declines.

In the early 20th century, several large estates were created by owners with significant business interests in New York City. These men acquired working farms that provided secondary income to the country squire and allowed him and his family to reside among the local population, not with them. These estate owners brought large house parties of guests from the city that enjoyed the beauties of nature in luxurious settings. Broadway actors and a burlesque queen enjoyed the anonymity of being "just folks" on smaller estates.

The development of the interstate highway system in the Eisenhower years saw Woodbury become an exit on the New York Thruway, as well as a starting point to Rip Van Winkle's Catskills, as Route 17 bent around the southern edges of the town. As vacationers left Woodbury to head to Catskill resorts, a new group of people found a home. The 1960s urban flight into the suburbs brought young families into the area, and Woodbury became, for many, a bedroom community.

In 1985, ground was broken for Woodbury Common on land given to the town by the Harriman family. The outlet center now contains over 200 stores. Today, that corner of Woodbury attracts international visitors seeking not fresh air and natural beauty in the valley between the mountains, but the bargains that are touted in half a dozen languages.

One

Early Days

Woodbury, originally home to the Lenni Lenape, was a place of natural beauty, with Woodbury Creek meandering through the valley, thick forests everywhere, and the imposing Schunnemunk Mountain in the distance. Visible from the valley, Schunnemunk translates as "the mount of signal fires."

Farming and iron ore brought early settlers. Records indicate that Nathaniel Hazzard was one of the first—perhaps the very first—to use the 1,500-acre patent granted to him in 1727. It is likely that Hazzard's Pond (now Cromwell Lake) got its original name from him. About 20 years later, a 2,000-acre patent was given to Thomas Smith, who built a gristmill around 1756, indicating that there were enough farmers to support this enterprise. Names of early families still linger, including Campbell, Cornell, Cromwell, Davenport, Dickens, Earll, Florance, Hallock, Lent, Pembleton, Seaman, Sutherland, Townsend, and Weygant. Diverse religions were present, with services initially held in homes until meetinghouses and churches could be built. Services were conducted by itinerant or shared pastors.

Large outdoor furnaces accompanied the discovery of iron ore. Mining became a major pre–Revolutionary War industry. Woodbury's role was supplying wood to make into charcoal that was then used to fuel furnaces, like the Forest of Dean and Sterling Forest Mines. The once lushly forested lands of Woodbury were stripped of most of their trees, replaced by soot and noise from the continuously operating furnaces.

While Revolutionary War battles did not occur in Woodbury, it did play a role. Colonial troops were stationed near Bond Street in Central Valley, guarding the road leading to West Point's rear entrance. Residents experienced raids for livestock and property from those loyal to Britain. Families were divided, like the Smith brothers, with Francis Smith leading the Woodbury Clove Militia and Austin Smith supporting the British.

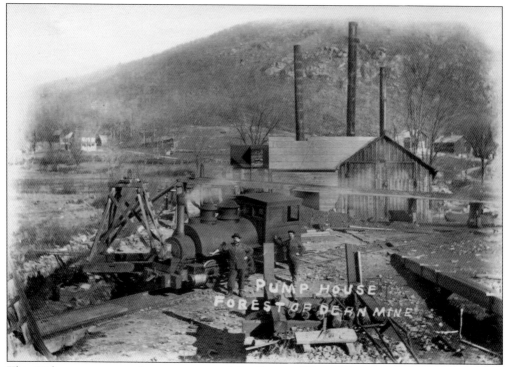

This 20th-century pump house was part of the Forest of Dean Mine. At 6,000 feet, it was the longest mine in the region. Located near Woodbury's border in Highlands, it was also one of the longest-operating mines, open from the mid-1700s until the late 1930s or early 1940s.

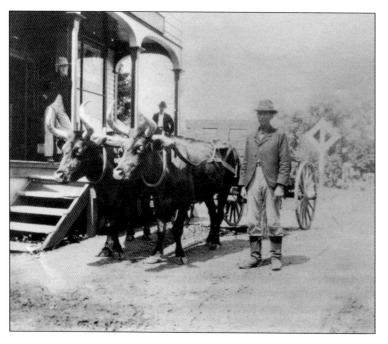

Around 1895, Samuel Bailey and his oxen arrived at the J.M. Barnes general store in Lower Central Valley, next to the Weygant's Carriage Manufactory. He was a descendant of Jacob Bailey, the founder of the Baileytown mountain community in the 1840s and a skilled charcoal maker for the Forest of Dean Mine. Baileytown, near Twin Lakes on Route 6, disappeared when it was absorbed into the Palisades Interstate Park.

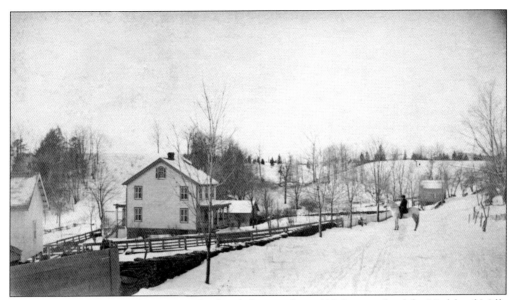

John Ford sits astride his horse near the family home, about 100 feet north of the Highland Mills Methodist Church. The Fords were early-18th-century settlers who became important business and community leaders.

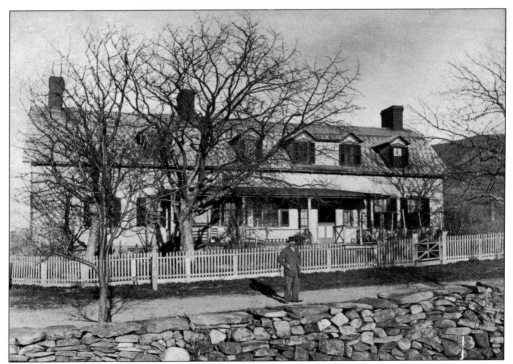

Located on Smith Clove Road near the Valley Forge development, the James Campbell House, built in 1772, was purchased by the family in 1806. Legend claims that Col. Jesse Woodhull was in the house when he was shot at by a member of the gang of the notorious Revolutionary outlaw Claudius Smith. The house survived into the 20th century but eventually fell into disrepair and was demolished.

Near the crest of Ridge Road in Highland Mills, the Foley farm is remembered by older residents. Originally owned by the Earls (or Earlls), another founding family, the property became Woodbury's popular recreational facility, Earl Reservoir, which was donated by Katherine Stainton. Schunnemunk Mountain is visible in the background.

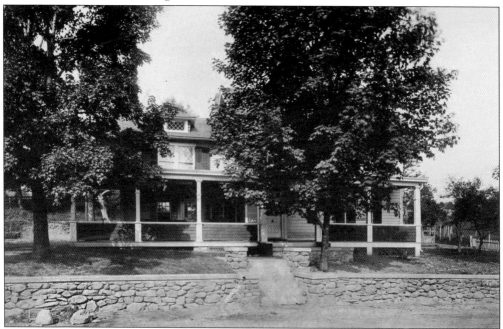

Built around 1750, this house occupied land owned by Aaron Burr, who is remembered for his famous duel with Alexander Hamilton. It was called Burrwood, after him and the Woodward family who later purchased it. It is doubtful Burr ever stayed there. The Revolutionary army may have camped near this house on its way to Newburgh. It survives today as office space across from the ambulance building.

Many early Woodbury settlers were Quakers, including the Schultz and Hallock families, shown here. They are seated in front of Allen C. Hallock's house, built about 1812. Henry Hallock Sr. is standing on the right. The house remains today, greatly altered, as a restaurant on Route 32 slightly south of Timber Trail. It was also once called the Old Mill Inn.

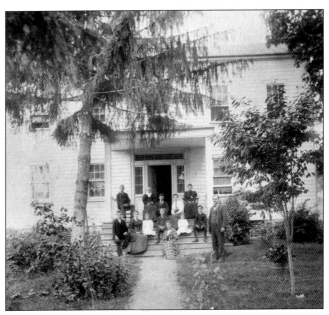

This 1919 photograph shows William Seaman in his Cole automobile at the family homestead, Sweet Clover Farm. In 1794, Samuel Seaman, a Long Island Quaker, was the first family member to settle here. Samuel was a founding member of the Smith Clove Meeting House. His son Thomas, through marriage to Sarah Brown, inherited what would become Sweet Clover Farm. Quaker services were held in the home's wide center hall.

This 1900 photograph shows the Smith Clove Meeting House, built by Quakers in 1801. The building followed a simple design: a single rectangular room with separate entrances for men and women, no pulpit or decorated windows, and an interior sliding panel used to separate the sexes during business meetings. To the right is a horse shed. One of the first Woodbury churches, it was added to the National Register of Historic Places in 1973.

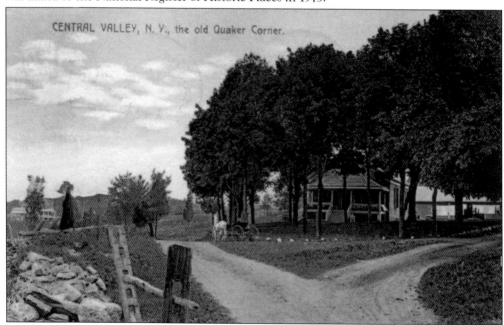

In the late 1820s, a national schism occurred between Orthodox and Hicksite Quakers. In Woodbury, the former relocated near the corner of Pine Hill and Smith Clove Roads, where they held meetings in a barn. Sometime later, the Orthodox group built a meetinghouse across the street, called the Stony Vale or Quaker Church House. Today, it is a private residence. Carriage mounting blocks remain.

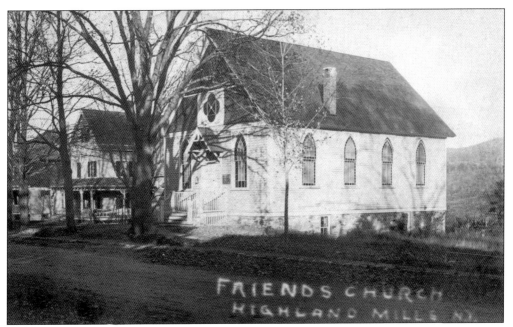

In 1896–1897, Orthodox Quakers built a new meetinghouse on Route 32 in Highland Mills. In 1912, it was rented for $1 a month to the Episcopal Trinity Mission, which began holding services there. About 10 years later, the church was renamed St. David's Mission. It continued as an Episcopal church until closing in 2010.

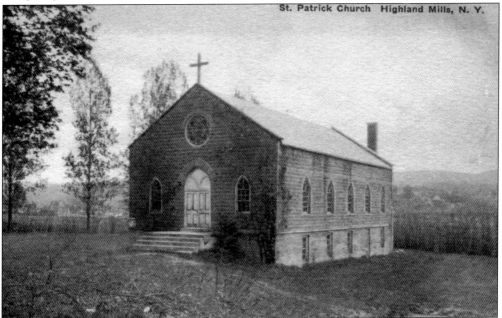

The cornerstone for St. Patrick's Roman Catholic Mission Church was laid in 1907. Previously, masses were held in Highland Mills, at the Knights of Pythias hall, which later became the town hall; in Central Valley, at the Valley Avenue school; or at Mrs. O'Sullivan's Hotel, near today's post office. In fair weather, a tent was erected slightly north of the construction site. A priest traveled from Harriman to conduct services.

Originally, Methodists in Highland Mills held services in homes with itinerant ministers, until building their first church around 1834. This 1859 building replaced that smaller church, which was sold and moved to become Weygant's Wheelwright Shop. The belfry was added in 1867, and stained-glass memorial windows were added in 1908–1909. The impressive polished stone balls on the adjacent cemetery entrance pillars came from a local quarry off Pine Hill Road.

Initially, Methodist services in Central Valley were held in rented space over Noxon's store, next to today's post office. Later, the Highland Mills minister led services on alternate Sundays at Institute Hall. In 1889, Richard Ficken, a prominent resident, donated land on what became known as Church Hill for the construction of the church. From the late 1930s to the mid-1960s, it shared a pastor with the Highland Mills Church.

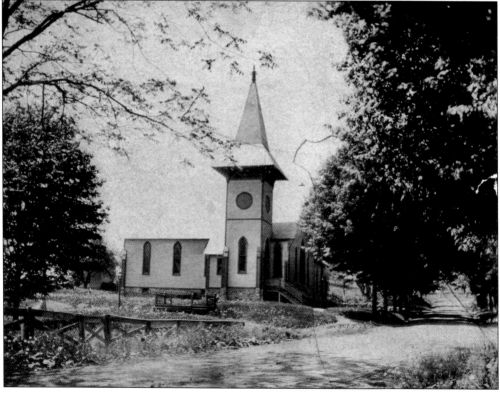

Two

Bring the Servants

Between August 1868 and July 1869, the Erie Railroad established a link of about 16 miles between Turner (now Harriman) and Newburgh, known as the Shortcut. Work was done mostly by Irish laborers living in hastily erected shanties along the right-of-way. Considering that work stopped during a strike, a slowdown during a drunken spree, a raucous St. Patrick's Day celebration, and, in January 1869, the accidental deaths of two workers, construction moved ahead at a remarkable pace. Although many local inhabitants eagerly awaited the railroad's completion, they mourned the loss of quiet and serenity that progress brought.

From the first, the railroad was a boon to farmers, who could now send their milk and produce into New York City. Soon, city dwellers discovered the delights of the Schunnemunk region. Salubrious air, locally grown produce, and fresh dairy products lured them to the area. An 1888 Erie Railroad brochure extols the virtues of life along the Shortcut, noting "the experience of years has demonstrated . . . that the air which circulates among these hills and valleys is possessed of curative properties that render the existence of pulmonary and bronchial affections next to an impossibility." In an era when consumption was the scourge of city dwellers, many listened and came.

Soon, sumptuous hotels and resorts sprang up to accommodate the wealthiest of vacationers. Advertisements that included rates for servants reflected the lifestyles of the clientele these hotels wanted to attract. With travel time of about an hour and a half from the ferry slip at Twenty-third Street in New York City to Central Valley, Highland Mills, or Woodbury Falls, businessmen could join their families in the country and commute to the city daily.

Local people profited from this influx of visitors. In addition to Woodbury citizens employed by the hotels, local businesses from livery stables and drugstores to contractors enjoyed additional patronage. Independent laborers sold their services as hiking, hunting, and fishing guides. During peak years, tourism was the second major source of income in Woodbury.

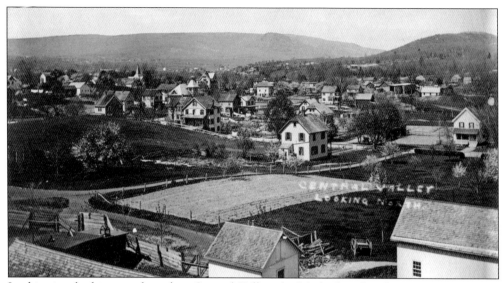

In this view looking northward up Central Valley, the Methodist church spire appears in the upper left. Note the closeness of the houses to the narrow dirt roads that carried horse-drawn carriages. An 1888 advertising brochure notes a population of 400, with two general stores and one drugstore.

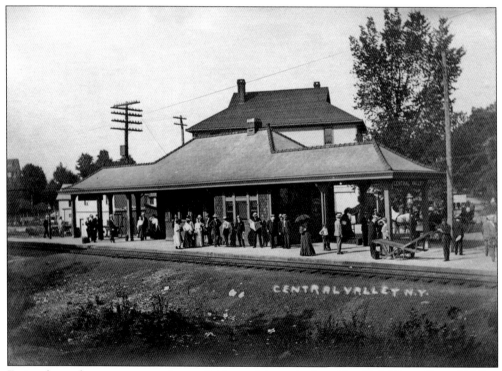

Facing the tracks, passengers await one of eight weekday trains from New York City to Central Valley, or seven returning to the city. The station, across from Weygant's Carriage Manufactory, is shown before it was moved and the tracks were regraded. Fashions of the day include panama hats and parasols. Central Valley Inn was a few hundred feet up Main Street (now Smith Clove Road).

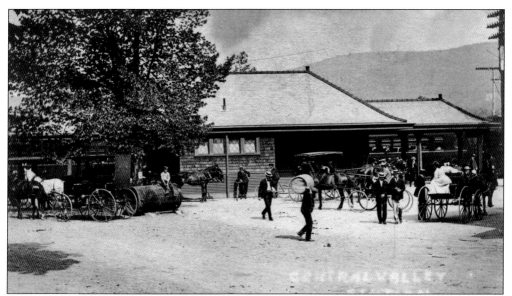

The train originally arrived in Central Valley with the tracks on grade level and the north side of the station on Main Street. Carriages waited to transport guests to the grand hotels and simpler boardinghouses, enhancing local incomes. There were four trains each way on Sundays. Local boys ran errands on bicycles while laborers carried barrels of goods to and from stores and farms.

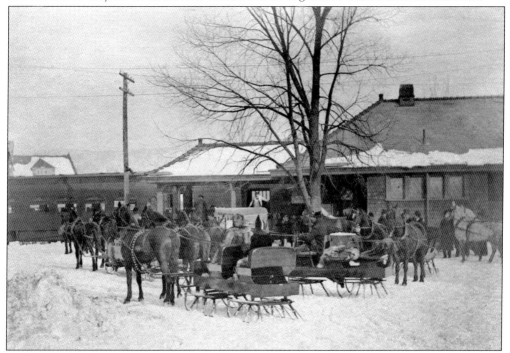

Jingle-belled horses and sleighs furnished with fur lap robes await winter passengers. Tickets one way were $1.45; round-trip was $2.00. Although hotel guests were fewer in number during the coldest months, larger resorts kept their main buildings open year-round. For the hardy, winter hiking and ice-skating were popular. Summit Lake House touted the highest toboggan ride in the United States.

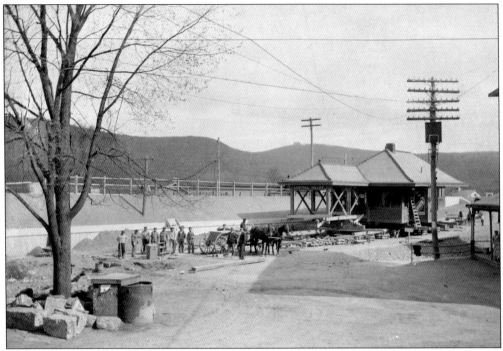

In 1907 and 1908, the Central Valley station was moved about 225 feet south and the railroad tracks were raised, creating an underpass at Main Street for pedestrians and vehicles. A century ago, the moving of structures was much more common than it is today.

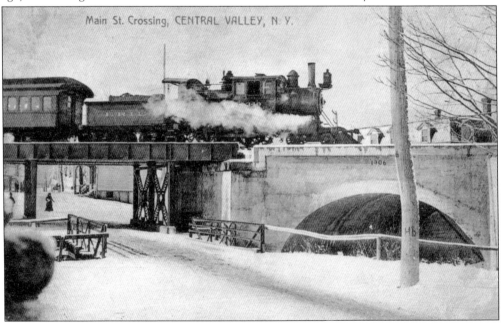

This photograph was taken along Main Street (Smith Clove Road) in Lower Central Valley, with a view looking to Upper Central Valley (Route 32). The bridge crossed Woodbury Creek; the aqueduct on the right remains essentially the same today. Elevating the tracks prevented periodic flooding while making the movement of vehicles and pedestrians safer and more convenient.

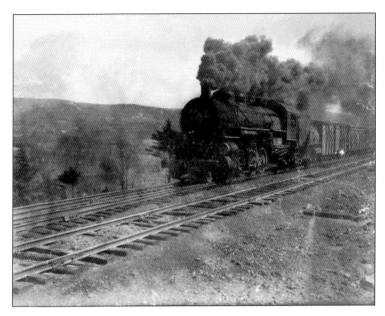

In 1919, this freight train passes through Woodbury, leaving behind sooty laundry, dangerous sparks, chunks of coal from open cars that will be scavenged by locals, and enthralled children who waved to the engineer and waited for his whistle. In the 1890s, Woodbury witnessed a six-day raging fire on Schunnemunk Mountain caused by train embers.

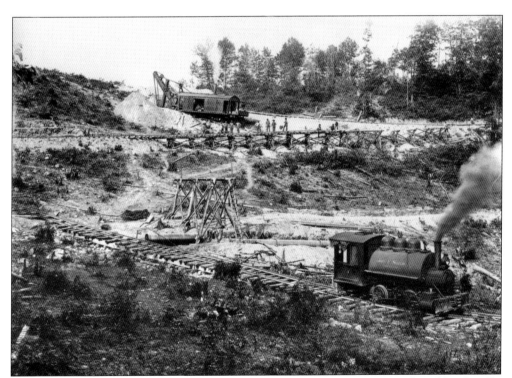

A steam shovel worked on the wood trestle cut between Central Valley and Highland Mills. Although called the Shortcut, it did not quite live up to its name, due to the nine stops on the 14-mile route. After Woodbury's three stations, it made stops at Houghton Farm (when flagged), Mountainville, Cornwall, Vails Gate, New Windsor, and Newburgh.

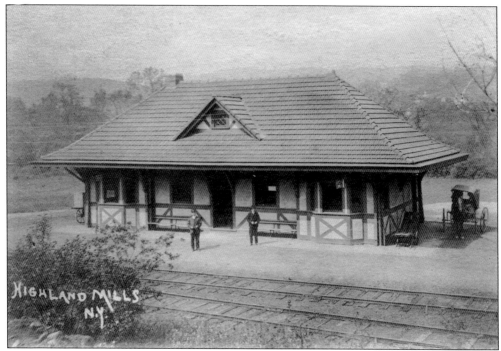

A passenger and stationmaster await the train at the Highland Mills station, located at the end of Railroad Avenue (today's Park Avenue). Fares and numbers of trains were the same as those to Central Valley. The chair-like object to the right is a wheeled cart for moving luggage. An 1888 advertising brochure lists a population of 500, a Methodist church, two Quaker meetinghouses, and good stores.

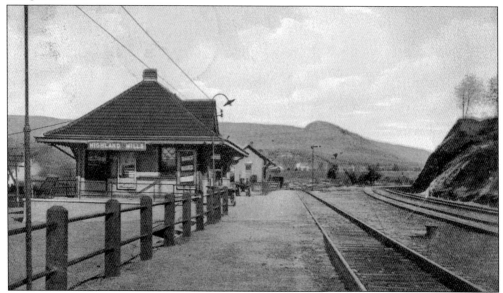

The station sat on the higher grade shortly after the Woodbury Creek bridge crossing. Slightly north of the station, the passenger trains departed from the freight line and headed towards the Woodbury Falls station on the older tracks. Before becoming Highland Mills, the area was called Woodbury Clove, Smith's Clove, and Orange.

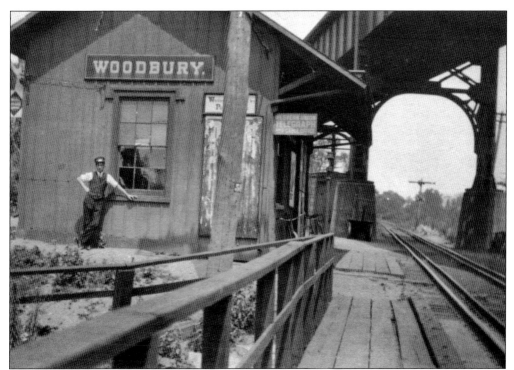

The ticket-seller stands outside the Woodbury Falls train station, the last stop in Woodbury. The sign above the door reads "Western Union Telegraph and Cable Office." The station sat where Route 32 makes a sharp curve under the present-day railroad trestle. The population was 300. Advertisements highlighted good fishing and hunting, as well as "romantic rambles."

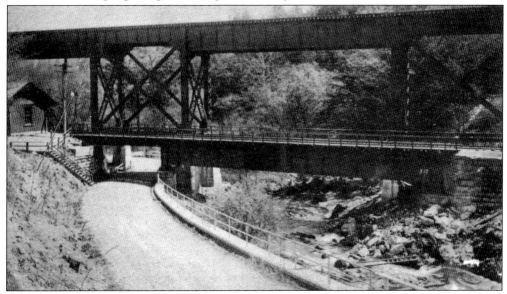

This photograph gives a sense of how important railroads were in the early 1900s. The Woodbury Falls station is on the far left. Note how close the station steps are to Route 32. The only danger was from a passing horse, since few automobiles were then in use. The lower train track carried passenger service, while the elevated track handled freight traffic.

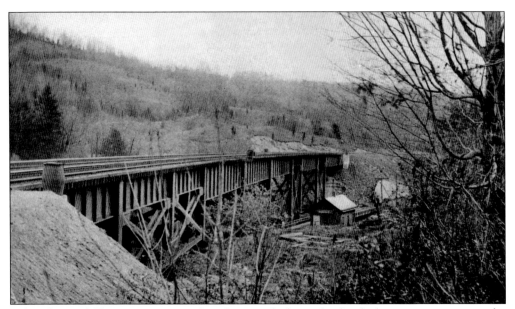

Taken from a different perspective, this photograph shows the freight line as it crosses over the passenger line and the Woodbury Falls station at the bottom right. The station post office opened about 1874. Looking out across the landscape, one can see how rural this area was and why it appealed to city dwellers seeking the rustic life.

Carriages transported passengers and luggage up the dirt roadway to the elegant Mountain Top House or the luxurious Summit Lake House via Mountain Road (now Estrada Road). This stream crossing is near the former Estrada Palma Institute, later known as Camp Wildwood. The two-mile trip to Summit Lake House cost 50¢ each way. An extra team of horses was needed due to the steepness of the road.

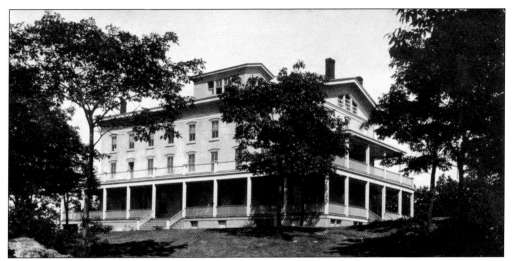

Mountain Top House presented an impressive silhouette. Constructed by Isaac Noxon in 1892, it was sometimes called the Stockbridge Mountain House after longtime manager Elisha Stockbridge. Built of concrete, it contained 40 rooms and could accommodate 150 guests on the two upper floors. Offices, reading rooms, a ladies' parlor, and a general parlor featuring a massive open fireplace were below. The basement housed the kitchen and dining rooms.

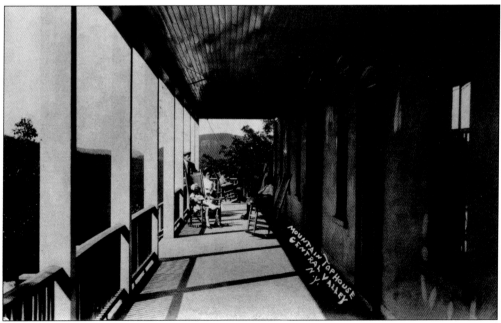

Relaxing in cool mountain breezes and enjoying magnificent views from the 12-foot-wide wraparound veranda was one of several pleasures enjoyed by guests. Advertisements touted the many nearby lakes, leisurely drives, and hikes. In 1910, all rooms were redone and updated, including the installation of lights, which made for a striking nighttime sight from the valley.

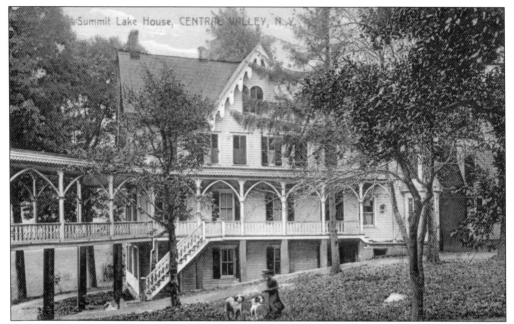

Also built by Issac Noxon, Summit Lake House, near the Twin Lakes, was another luxury destination. The main hotel contained 52 rooms, and there were also numerous cottages connected by piazzas. Daily rates were $10–$14 per adult, $7 for children, and $2–$3 for servants. The hotel stayed open year-round, providing its own post office and local and long distance telephone service, plus its renowned toboggan slide.

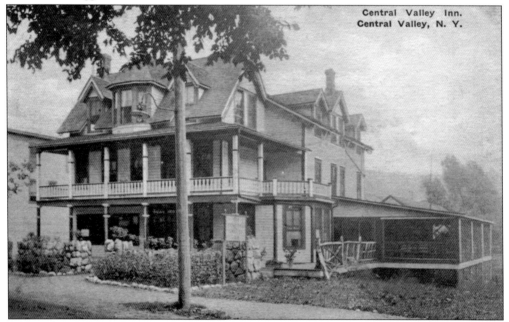

Although perhaps originally a spacious private residence, the Central Valley Inn became a popular hotel before the end of the 1800s. Its location, near today's firehouse, made it convenient for train passengers. The inn had many proprietors, with Henry Goff being one of its most successful. It was abandoned and fell into disrepair, resulting in its eventual demolition in 1942.

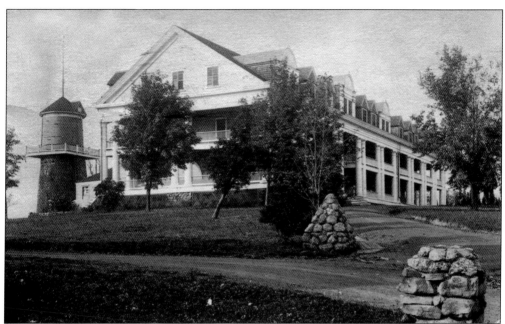

Hillcrest Hall, erected in the 1890s, was a fashionable hotel on Cromwell Lake in Highland Mills. The structure to the left in the photograph above is a water tower. Walter J. Reed, its first manager, took special care maintaining the beautiful stone piers marking the entrance, which were enhanced with landscaped tiers of flowerbeds along the roadside. Carriages waited at the train stations to transport passengers up the hill past this colorful welcome. Over a dozen horses with buggies and carriages were housed on the property for guests to use for outings. By 1906, automobile service to and from the station replaced carriages. In the spring of 1921, while carpenters and plumbers were making improvements in advance of the summer season, the main building was destroyed by fire.

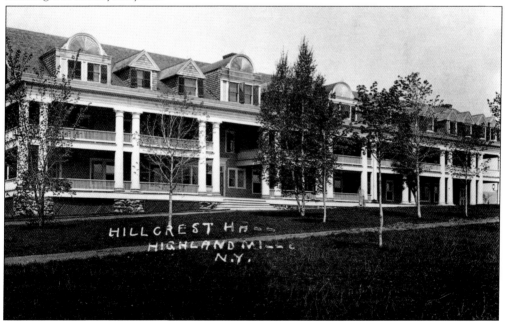

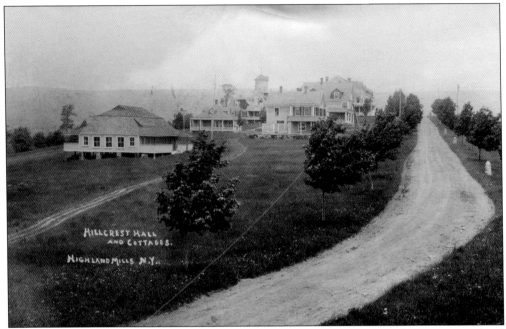

Hillcrest also had five or six cottages available for families. Up to 250 people could be accommodated at this year-round facility. In winter, guests would be conveyed in a tram or a three-seated sleigh decked out with silver bells and long red tassels. One thrilling winter activity was the toboggan slide. Although it was smaller than the slide at Summit Lake, it extended onto frozen Cromwell Lake.

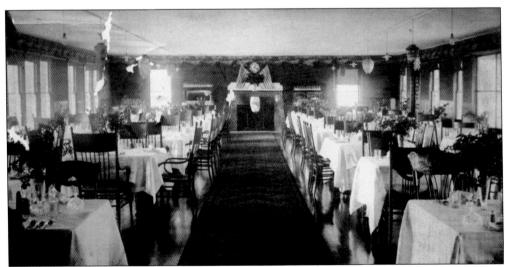

Diners at Hillcrest ate meals prepared by Alois Muckenhoupt, a Vassar College chef who later opened a successful greenhouse business on Forest Avenue that operated for 43 years. People did not casually wander in for dining. Instead, meals were served at specific times. Tables were set with linens, flowers, and dinnerware. Walls of windows provided light and cross ventilation, as well as rustic views.

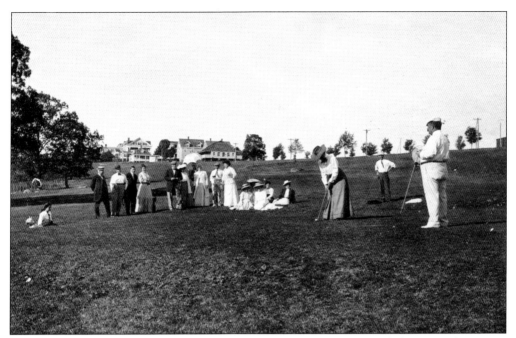

Hillcrest, whose property extended from Route 105 to Ridge Road, provided a range of activities on the premises, including golf. Local boys were hired as caddies. The hotel had to adapt to the changing desires of its clientele in order to remain competitive. For example, it allowed businessmen to keep in touch with their New York City offices on one of the first telephone lines in Highland Mills.

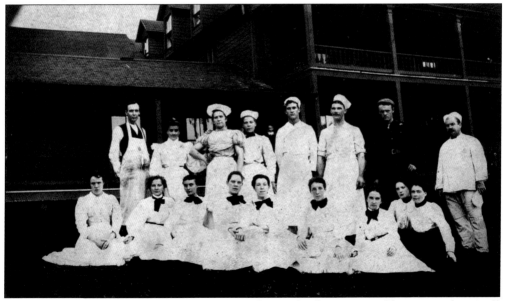

Local folks worked behind the scenes to serve the needs of guests. In addition to indoor staff, an outdoor staff tended to the lawns, flower beds, and the dozen or more horses stabled on the grounds, plus the carriages and buggies. Upkeep of the many recreational areas also required specialized staff. Guests could hire local fishing and hunting guides. Staffing these hotels provided many local jobs.

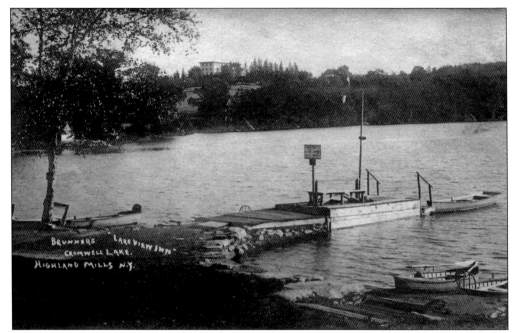

Cromwell Lake was a mecca for guests looking to enjoy the country. In the foreground is the dock for Brunner's Lake View Inn, a popular lakefront destination. On the south side of the lake, rising on the hillside, is the four-story, 70-room Cromwell Lake House. Some claim the lake took its name from this hotel, as opposed to the other way around.

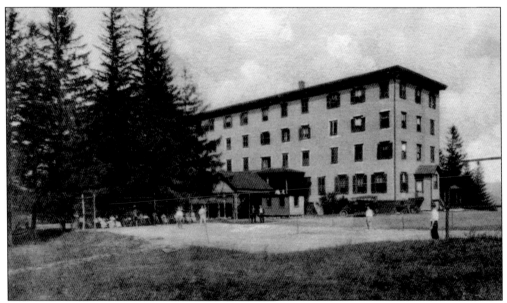

Built and owned by Oliver Cromwell, Cromwell Lake House could accommodate 150 guests at its main building and cottages. Guests were charged 25¢ for the 1.5-mile trip from the train station. A tennis court and a bowling alley were available. In winter, there was evening ice-skating with shoreside bonfires.

Located at the intersection of Rose Lawn Road and Route 32, Rose Lawn Farm, named for its blooming roses, was a "classy" nine-room hotel owned and operated by Aaron Taylor until his death in 1913 at age 82. Henrietta Clark, his second wife, continued operating the hotel until it burned on New Year's Eve, 1916. Guests had to "apply" at the desk to take a bath, for 25¢, and were charged the same amount for lights after 10:00 p.m. Guests without luggage were required to pay in advance. Meals were served at scheduled times: breakfast at 7:30 a.m., lunch at 1:00 p.m., and dinner at 6:00 p.m. On Sundays and holidays, the hours were breakfast at 8:00 a.m., dinner at 1:00 p.m., and tea at 6:00 p.m.

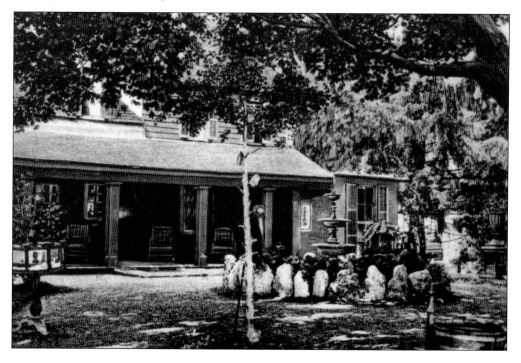

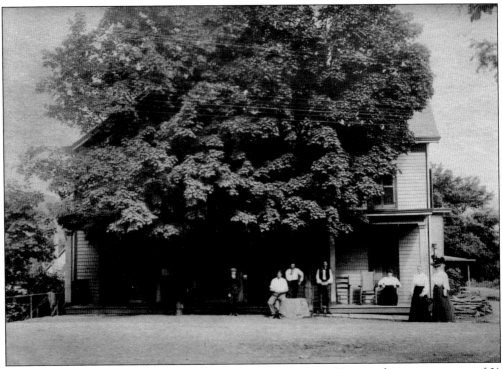

The Highland Mills Hotel, also called the George Lamoreaux House, after its proprietor of 31 years, stood on the corner of Park Avenue and Route 32. It offered seven guest rooms and had fishing and hunting guides available for hire. The site of the first meeting of the Woodbury Town Board in 1890, it was replaced by the larger Goff Inn in 1923.

The 14-bedroom L.A. Van Cleft house was an upscale boardinghouse located on a lake about 1,000 feet southwest of the Woodbury Falls train station. Daily rates were $8–$10 for adults, $3 for children, and $2 for servants. Van Cleft was the first Woodbury Falls postmaster. In the early 1900s, the lake was drained and the house was torn down.

Three
BOARDERS PITCH IN

Not everyone coming to Woodbury for extended stays was wealthy. Teachers, ministers, shopkeepers, and their families also wanted to enjoy the benefits of life in the mountains. As the railroad continued to advertise the virtues of towns along its route, farm families with large houses or outbuildings that could be converted into places for boarders began to offer accommodations. Owners' children might sleep in tents so that their rooms could be rented. Some owners required references, and others gave discounts for staying the season.

Life on farms and boardinghouses was different from life at luxury hotels. Guests often pitched in with farmwork and were almost part of the family. They were more likely to make their own beds rather than have a member of the busy host family do it for them. Meals would be served family-style around a communal table, as opposed to the formal service expected at the carriage trade establishments.

Because many of the boardinghouses were part of a working farm, the boarders found their own entertainment rather than having it provided for them by a staff dedicated to that purpose. Hikes to lakes or waterfalls were popular diversions. Afternoon card playing under the shadows cast by spreading elms or pitching horseshoes behind the barn cost little. Those who boarded with the same families every year pitched in to do yard work or help tend the gardens that provided the fresh produce they enjoyed.

Because of the personal relationships these boarders often had with host families, and because they often viewed the boardinghouse as a second home, they continued to come until World War II, long after the upscale hotels had closed.

On the way up the mountain to the luxury hotels was the simpler Bush Hotel, on Route 6 (today's Estrada Road). Taken in 1898, this photograph shows the Bush family. They are, from left to right, Ralph, George, Maude (on horseback), Edna, Ethel, and Pauline (on the stairs), and Hudson (holding baby Leon). Hudson Bush was a blacksmith and the town constable.

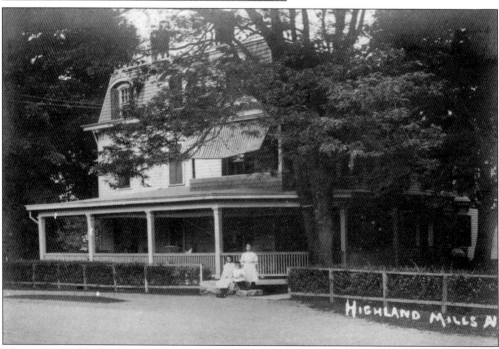

This recognizable dwelling on Route 32 in Highland Mills was known as the Townsend House, later the Horsechestnuts, and then the Paas House. Originally without porches, it was a family-run inn of 16 rooms around 1900. The lawn had a visible outline of the foundation of what was perhaps a very early building in Woodbury. These children are sitting on a mounting block for ascending a horse.

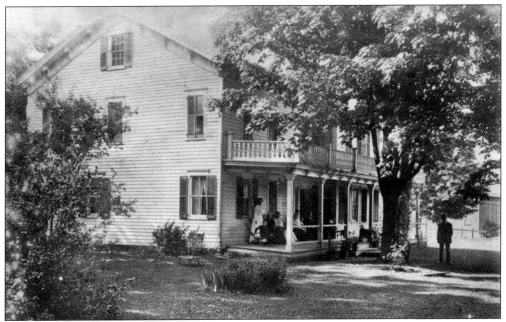

Although lacking a sizable business district like that of Central Valley and Highland Mills, Woodbury Falls competed for the tourist trade by promoting the great outdoors. The 11-bedroom Mary Cornell House, shown in 1905, advertised excellent fishing and gunning. For those less energetic, its shaded two-story porches were an invitation to relax and take in the scenery during the warmer part of the day.

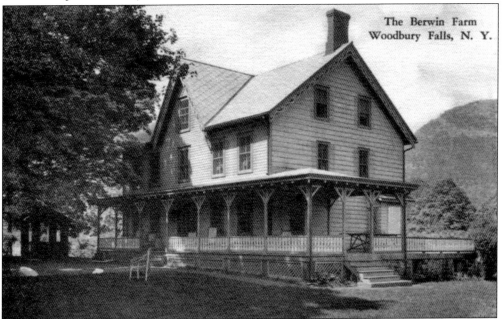

Berwin Farm, in Woodbury Falls, was a destination for boarders of modest means. Inviting rocking chairs on the porch, views of Schunnemunk Mountain in the background, and Woodbury Creek, down the hill, made for a pleasant stay. The house still stands at the intersection of Route 32 and Trout Brook Road.

The Helbing farm was located on Mineral Springs Road in Woodbury Falls. One Christmas in the late 1930s, longtime boarders presented the Helbing family with skis and poles. Skiing and sledding were enjoyed on the sloped area in the foreground. Another year, the Helbing children received ice skates. The family and the boarders skated on the pond, which is now part of a golf course.

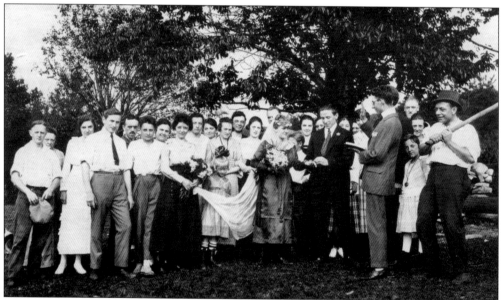

This mock wedding took place before 1923 at the Helbing farm. Choosing the main participants was a much anticipated activity, and picking unlikely candidates added to the entertainment. It was also a good excuse for a celebratory party afterwards, when everyone followed "the couple" to the outdoor reception. Note the fellow on the right with the baseball bat, perhaps indicating a "forced marriage." (Courtesy of Dorothy Helbing Morris.)

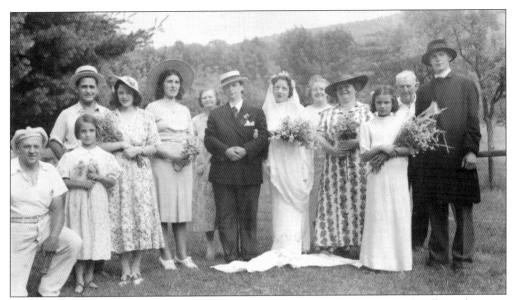

Almost 20 years later, mock weddings continued, with a second generation of Helbings hosting. The "groom" was the mother of the "preacher," living-room curtains were the bride's gown, and field flowers were bouquets. Everyone worked all day to create a festive reception. Mock weddings were an imaginative form of summer entertainment for boarders and farm families. (Courtesy of Dorothy Helbing Morris.)

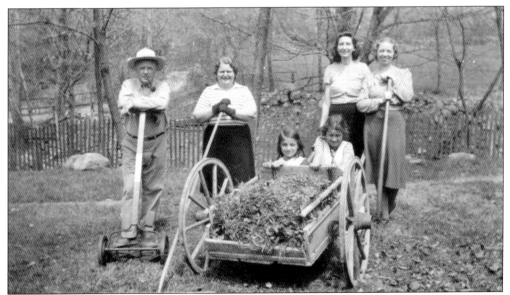

More than fall cleanup was in the air in the late 1930s. The boarder on the left met and married the schoolteacher on the far right, another boarder. Longtime resident Dorothy Morris is the child on the right behind the cart. Doing chores kept everyone fit and gave a sense of family to strangers who met on the farm. (Courtesy of Dorothy Helbing Morris.)

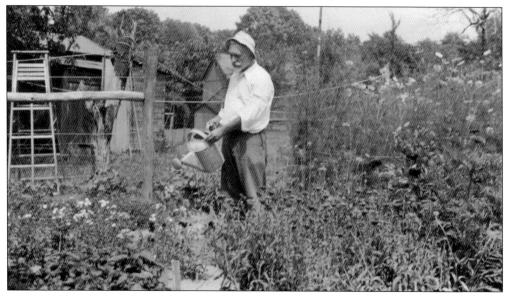

Mr. Pittner, a retired chemist, spent much of his time at the Helbing farm. This June 1935 photograph shows him watering the gardens he so enjoyed, which he took responsibility for planting and maintaining. The boarders pitched in to build the garden house in the background. (Courtesy of Dorothy Helbing Morris.)

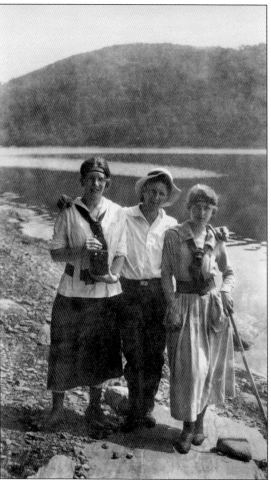

In this image taken before 1920, these boarders, in comfortable attire, have hiked to Popolopen Lake. Bare arms, flat boots, shorter skirts for the girls, and no tie or jacket for the boy show the casualness that recreational dress had assumed. The girl on the left is holding a Brownie camera, which sold for $1 at the time and made picture-taking popular and affordable for the general public. (Courtesy of Dorothy Helbing Morris.)

Boarders, some with walking sticks, and a dog climbed the rocky hills in the snow to reach Mineral Springs Falls, a popular year-round destination. Boarders stayed at farms and houses in Woodbury throughout the year. Many left clothing and other belongings at their "home away from home."

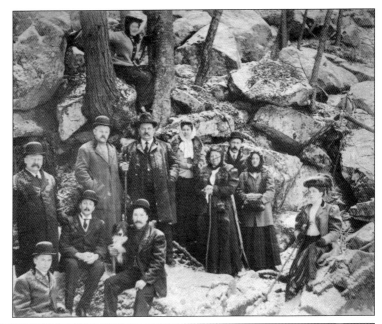

The area's plentiful streams provided opportunities for fishing and outdoor relaxation during spring, summer, and fall. This corseted, fashionably dressed lady with a smart hat is monitoring her fish line in the water while two young boys look on. Obviously, their formality of dress was not compromised, either for safety or comfort.

Known as the Black Forest Inn Restaurant since 1978, this structure was built by John W. Ford and operated as a boardinghouse. The many windows made for good cross ventilation and natural light. Summer days could be enjoyed on the porch or in the shady yard. In 1962, it was called Highland Manor.

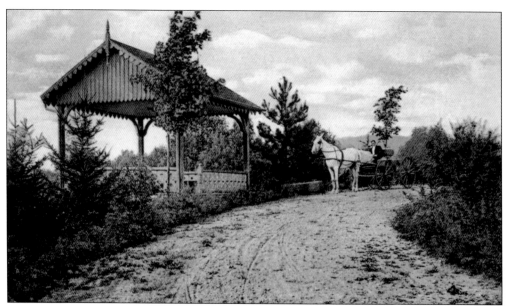

In the late 1800s, Richard Ficken, a prominent resident, created a 60-acre public park straddling both sides of Smith Clove Road. Called Scharmbecker Park (and also Lime Rock Park), it contained miles of winding carriage paths and walkways with gazebos and seats for resting. One of Ficken's proudest achievements was the construction of the beautiful rustic bridge, which has since been repaired and remains at the entrance to the Greens of Woodbury.

Four
CENTRAL VALLEY BUSINESSES

Prior to the railroad's arrival, Central Valley was not even on maps, but it had many identities. The area known as Upper Clove was along the New York–Albany Turnpike (now Route 32). Lower Clove was along Main Street (today's Smith Clove Road) and Academy Avenue (now Valley Avenue). It was also called Smith's Clove. Once the railroad arrived in 1868–1869, the hamlet was given the name Central Valley, and it was eventually split into Upper and Lower Central Valley.

Railroads made Lower Central Valley the focus of business. It is said that Robert Weygant, the owner of the famed Weygant's Carriage Manufactory, donated land as an inducement for the railroad to build the station near his building rather than in the slightly more populous Highland Mills. In fact, a rivalry developed between the two communities over which would get a station. The story goes that the railroad initially approached a Highland Mills businessman about purchasing land for a station. But, disliking the price, the railroad accepted the offer of free land from Weygant, a shrewd move on his part. Highland Mills businessmen found themselves at a disadvantage with the new station over a mile away and felt there was no choice but to pay to build their own station.

Central Valley station was a boon to the establishment of new businesses and the growth of existing ones. Hotels, livery stables, creameries, dry goods and general stores, and even private schools benefited from proximity to the railroad. With multiple trains arriving daily, Lower Central Valley became a busy hub of passengers and produce. Local farmers greatly benefited from being able to ship their products more frequently and efficiently to markets farther away. Trains brought tourists and business to this area, as cars would later do for the Borscht Belt resort trade of Sullivan County.

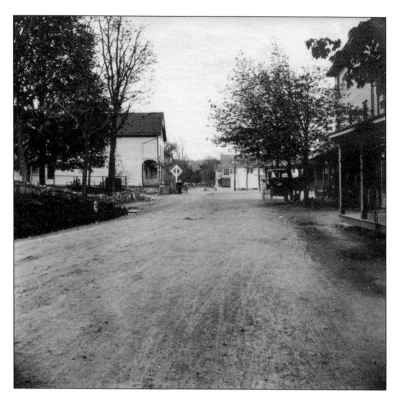

Before the tracks were elevated, the diamond-shaped sign in the left center indicated the grade-level tracks in Lower Central Valley in 1907. On the far side of the tracks, on the right, is Simon Nelson's department store (near today's Laundromat), which sold clothing and expanded into furniture sales. On the right, a horse and carriage is hitched in front of Ford's Department Store.

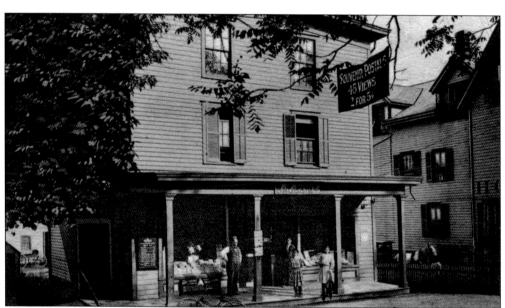

Shaw's drugstore was proud of its 45 different postcard views of interesting local places. Businesses contracted with photographers to take snapshots that were made into postcards sold exclusively by that store. In the era before smaller, personal cameras were available, postcards gave the folks back home a sense of place. Shaw's was to the left of the Central Valley Inn and in front of a large livery stable.

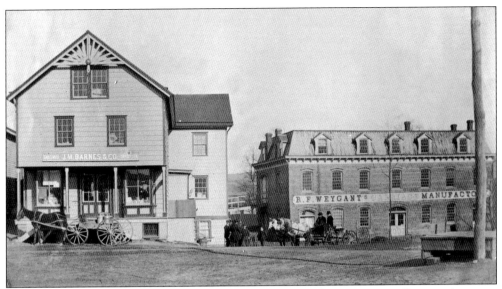

In 1904, on the north side of Main Street, across from Ford's Department Store and next to Weygant's Carriage Manufactory (right), there were two frame buildings. Only one of them is visible here, the Cooper and J.M. Barnes general mercantile store. Barnes eventually became the sole proprietor. Shortly after train service began, the post office was opened here in 1871.

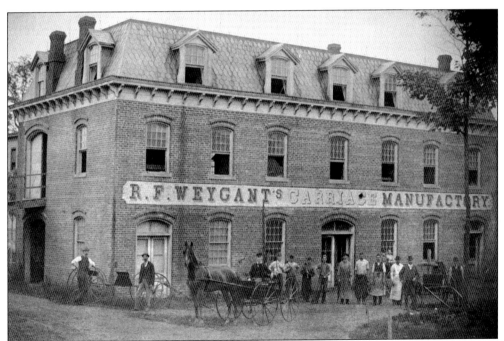

In 1868, a few years after the Civil War, Robert F. Weygant began manufacturing quality horse carriages at the shop that bore his name on Main Street in Lower Central Valley. Weygant also rebuilt carriages and sleds in his fine new mansard-roofed brick building. The door on the upper left opened to a long ramp leading to the second floor (also visible in the previous image).

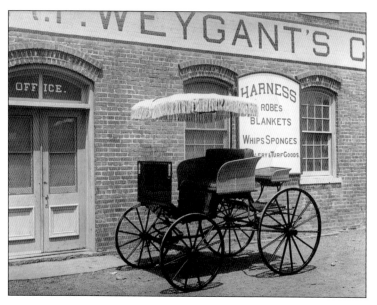

This carriage in front of Weygant's establishment was known as a spider phaeton, based on a model of British design. With rattan seats and a fringed, open top, it was made for use in warm weather and could be hitched to either a single horse or a pair of horses. This conveyance was fast, well-sprung, and known as a "gentleman's carriage."

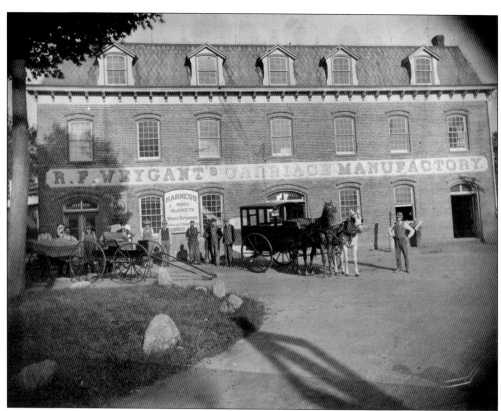

In a later photograph, workers at Weygant's proudly display diverse examples of their craftsmanship. On the far left is a utilitarian cart, and to the right is a two-seat open buggy. The vehicle hitched to the horses is an omnibus, possibly used by a grand hotel to transport its guests. The company also sold harnesses, saddlery, robes, and blankets.

In 1913, identical twins C. Henry and Theodore Jones (order unknown) founded the Jones Brothers stove and hardware store in Lower Central Valley. Electric wires are strung neatly along the ceiling, with a lone fixture visible to highlight the goods for sale. Coal and wood-burning stoves, baths and toilets, bicycle wheels and buckets, stovepipes, and hardware are displayed for customers.

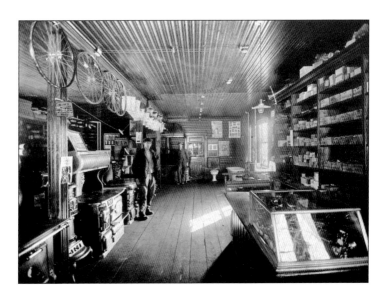

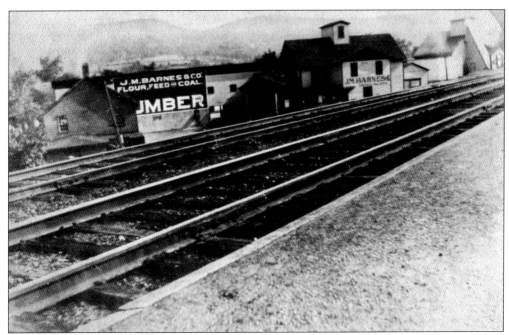

Around 1897, J.M. Barnes sold his general store. About 1903, he established his coal and feed store on the other side of the railroad tracks, parallel to Valley Avenue and extending south to Laura Lane. Lumber was added to the business, which continued to grow, gaining a notable reputation in the area.

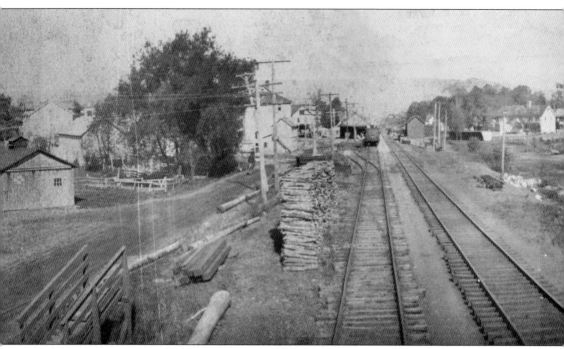

This is a wider view of the J.M. Barnes business around 1905. The tracks to the left are for the Newburgh Shortcut passenger and freight trains into Central Valley and beyond. On the right is the spur line going into the J.M. Barnes coal, feed, and lumber buildings. In 1911, Barnes added

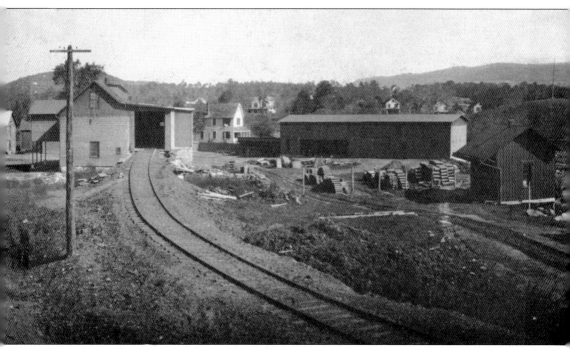

a partner, his nephew Morgan Shuit Elmer. The business was renamed Barnes & Elmer Lumber Company. By 1925, the company added flour, building materials, paints, lime, cement, and doors for sale. The business had about 15 employees when it burned to the ground in 1941.

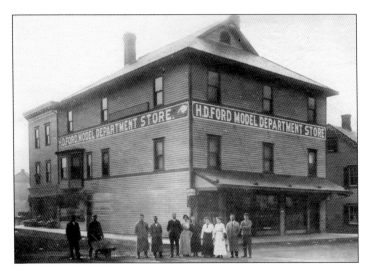

The staff of the H.D. Ford Department Store stands proudly in front of its building, which fronted on Main Street with Valley Avenue intersecting at the left. Ford is fifth from the left. By 1914, Jean LeFloch owned the building. Although the porch is now gone and new siding and fire escapes have altered its appearance, the building still stands today in Lower Central Valley.

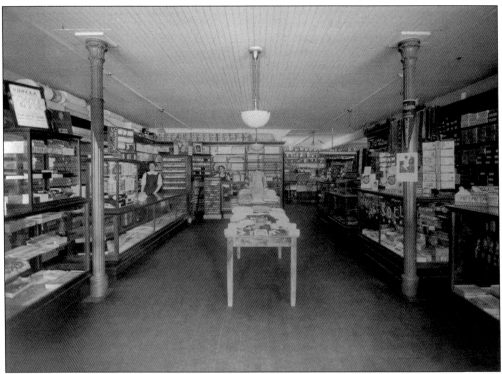

The Ford Department Store was divided into dry goods and grocery sections. The dry goods section, where these two ladies stand ready to serve, sold clothing, fabric, toiletries, clocks, hosiery, gloves, paper goods, and more. String, hung from the ceiling above the counters, was used to tie purchases wrapped in plain paper. Purchases were noted individually in an account book that was settled on payday.

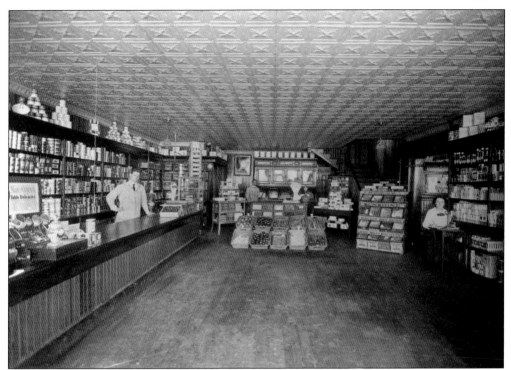

Canned goods and boxes neatly line the shelves on the grocery side of the Ford Department Store, and baskets of produce and various crackers are attractively displayed. The telephone girl on the right is ready with her pencil and pad to take orders that would be delivered to the home. The entrance to the dry goods part of the store is directly behind her.

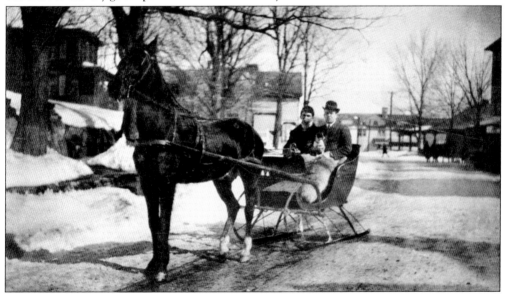

This photograph, taken before 1907, shows two men and a dog riding along Main Street towards Upper Central Valley with the heater of the day, a fur lap robe. Snow was packed down by giant horse-drawn rollers, making it easier for sleigh runners to glide along the roads. The J.M. Barnes store and the post office are in the background to the left.

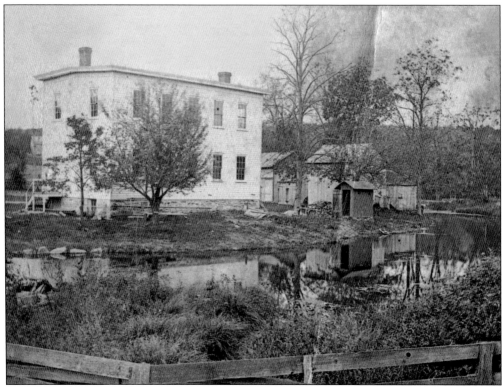

The H.L. Leonard Rod Company came to Central Valley in 1881. It was founded by Hiram L. Leonard, the "father" of the modern fly rod, who perfected the first successful six-strip beveled cane rod. The business, on Laura Lane, is seen above in 1895. By 1903, the building had added a three-story wing, as seen below. Insurance maps describe the premises as coal-burning, with steam heat and gasoline-powered lights. The first floor was for metalworking; the second for woodworking, mounting, and varnishing; and the third for bamboo splitting. By 1925, power and lights were electric. In 1964, the building burned to the ground in a disastrous fire, destroying the secret antique beveller still in use, as well as the entire rod stock. A one-story cement block building was then erected about 100 feet to the right. Local operations ceased in 1984.

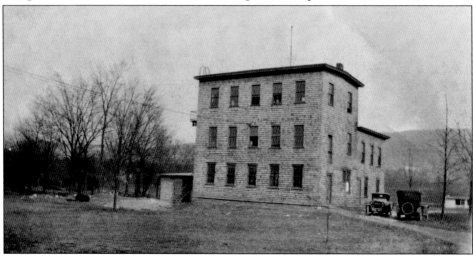

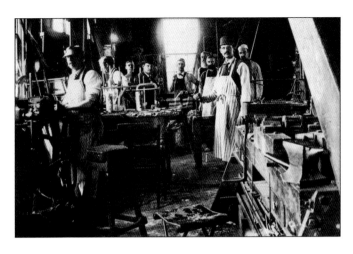

Prior to moving to Laura Lane, the Leonard Rod Company was housed in a small building behind Weygant's Carriage Manufactory. These unidentified men are working on fly rods in that building in 1887. The beveller invented by Hiram Leonard is not shown; a story tells of it being so secret that it was kept behind a locked door. Only Leonard and his manager were allowed into the room.

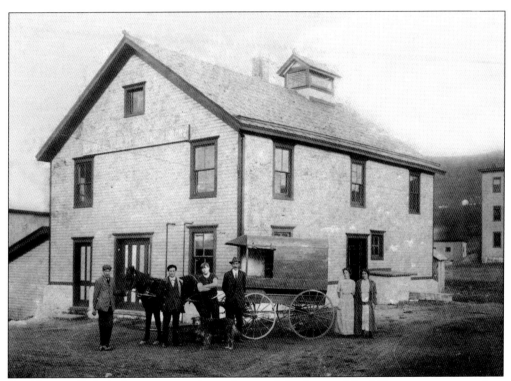

For 20 years, Rider's Creamery was located west of the Leonard Rod Company, a convenient location for shipping milk by rail. It closed about 1906. By 1909, the building was the Central Valley Laundry, and it later became Percy Redner's first garage. These laundry workers are, in no particular order, Ray Blauvelt, Ivan Mapes, Ed Osterhout, Mamie Shear, and Ethel Moulton. Baileytown teenager Bessie Bailey was one of the 15 employees, and George Lent delivered the laundry.

In 1906, when Lower Central Valley was the hub of activity, Cornell's drugstore sat alone in Upper Central Valley, on the lightly traveled New York–Albany Turnpike. Slightly beyond the store, one can just see the turnoff to the right for Main Street (Smith Clove Road).

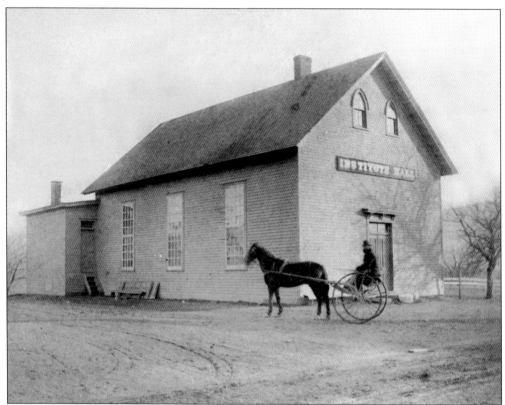

Around 1890, Frank J. Nearn purchased Institute Hall, formerly David Cornell's school, on the corner of the New York–Albany Turnpike. He established a livery service in the back and converted the front to Nearn's Opera House, a grand name for space that was rented for vaudeville performances, moving picture shows, dances, and plays. Later, it became Barnhart's grocery store, and then Redner's sales and service for Pontiac automobiles.

This livery stable, on the northwest side of the intersection of Dunderberg Road and Route 32, belonged to George Lent and was one of many such businesses transporting guests to hotels and boardinghouses. Guests rented carriages for pleasant country drives. Another stable was behind the Central Valley Inn.

The ice industry was a major local business and winter employer. This 1907 photograph of Rider's Pond (now Central Valley Pool, donated by Edward Cornell for recreational use) shows men harvesting ice, which was then cut into blocks and pulled by horses for storage in specially designed structures packed with sawdust, hay, and wood shavings to keep the ice chilled for summer use. Lack of electricity made stored ice a valuable commodity.

This 1910 photograph captures the time between the paving of Route 32 and the ascendancy of the automobile. To the right is Main Street. A plethora of signs at the junction of these roads is intended for the motoring public, some of whom were perhaps unfamiliar with Central Valley. Arrows point to West Point, Weygant's Garage, Simon Nelson's store, and O'Sullivan's eatery. Except for the sign for the last business (right), they are primitive and nailed onto a pole.

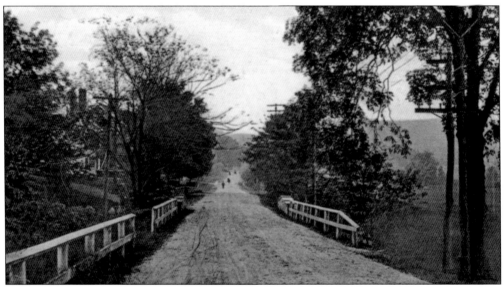

Looking north along Route 32 from Central Valley, one can barely see Burrwood, the pre–Revolutionary-era Burr and Woodward house, on the left behind the trees. Power lines are strung along either side of the road, and a few pedestrians and a horse and buggy are in the distance. Local life revolved around each community's center, family, and friends.

Five

HIGHLAND MILLS AND WOODBURY FALLS BUSINESSES

Driving along Park Avenue, one would be hard-pressed to find reminders of its past importance as a vital Highland Mills business area. Only a few isolated remnants are visible, and even those are bypassed unless one looks carefully. A lone roadside stone pillar in someone's front yard once adorned the entrance to Adams Hotel, noted for offering a unique alcoholic beverage, apple whisky. The decorative ball on top and its matching pillar across the entrance are long gone.

Standing across the street is a brick building that housed various businesses, including the Adams Garage. Behind this structure, towards the sharp curve in the road where a small bridge crosses Woodbury Creek, stood an unusually long building housing the Hall Line Company. It slowly deteriorated until it was demolished near the end of the 20th century. Just over this bridge was the Highland Mills train station, which was likely why the roadway was called Railroad Avenue. Also gone are the days when cattle would arrive by rail and be driven up the avenue and along Route 32 to whichever farms had purchased them.

On the corner of Park Avenue and Hollis Street sat the impressive George Cromwell & Sons general goods and hardware store, which also sold coal and lumber. It filled the corner, with offices built over the stream and a large lumberyard. If one drives slowly, a small portion of the stone wall is still visible. The revered E.J. Payne Company, manufacturers of world-famous fishing rods, sat on the corner of Hollis and Elm Streets. It is now a private residence with no trace of its former use.

On Route 32, then known as Main Street, the former post office building remains, across from the town hall. Today's flower shop was a drug and general goods store that passed through numerous owners. These two streets and Route 105 formed the business district.

Remnants of Woodbury Falls' early businesses are now only memories. They include a furnace operation and mill, a general store, a creamery, blacksmith shops, icehouses, and the last commercial charcoal pit, operated by Louis Gross Sr.

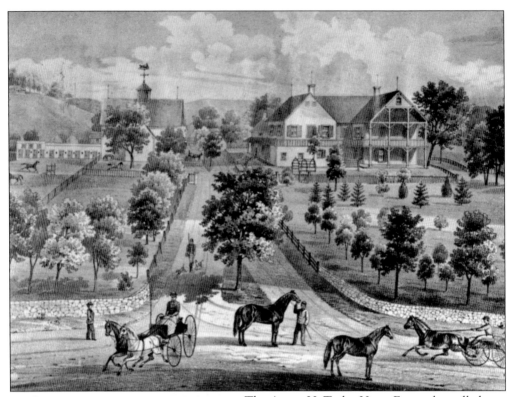

The Aaron H. Taylor Horse Farm, also called Rose Lawn, enjoyed a wide reputation in the equine world by virtue of its producing champion pure-blooded trotting horses. Taylor had always lived on this land, which had been purchased by his grandfather in 1790. In his younger days, he bred and raised racing horses here. Later, part of the property became the Rose Lawn Hotel. Taylor is seen here with his first wife, Gertrude Culver. Records indicate that a sign was placed on Route 32 acknowledging his donation of the Central Valley baseball field and grandstand. He was given the honor of tossing out the opening game ball. After a 1916 fire destroyed the hotel, the property was divided and sold. The barn was converted into apartments.

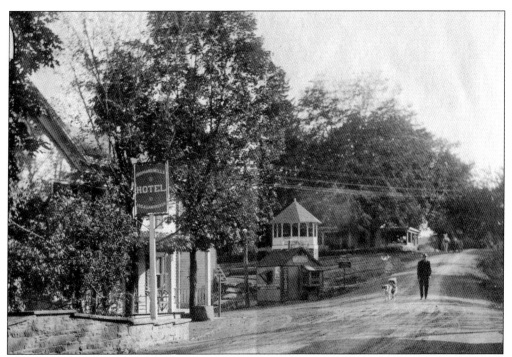

The wooden bandstand, which was replaced by a stone structure in 1920, helps date this photograph. A man and his dog and a horse and wagon approach the corner of Route 32 and Railroad Avenue (Park Avenue) in Highland Mills. The sign on the left identifies the Highland Mills Hotel. Louis Earl's Soap Box store stood between the bandstand and the hotel, with the gristmill down Park Avenue behind his store.

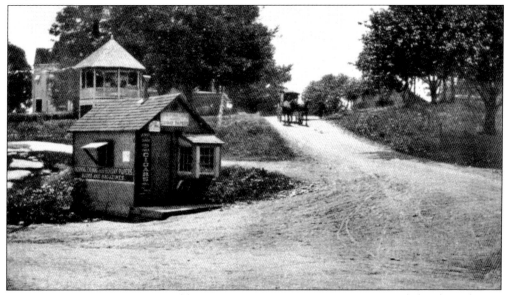

Louis Earl's popular Soap Box sold New York City newspapers, candies, and the "best" home-roasted peanuts. It was a landmark from the late 1890s to 1908, when the widening of Route 32 caused its demise. The nearby bandstand was originally on the corner of Elm Street and Route 32 before being moved to this location around 1906.

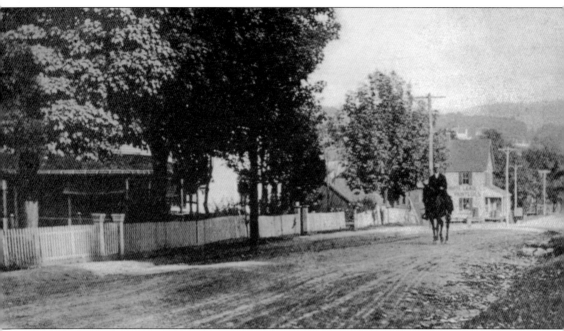

Riding down Railroad Avenue from Route 32 to the train station, this horseman might have stopped for cattle being unloaded or visited one of the businesses lining the street—the gristmill, the Cromwell Store on the corner of Hollis Street, or the Hall Line Company. Located at the corner of Route 32, Thomas Smith's gristmill, not visible, burned about 1773 but was rebuilt. There was an open millrace at the top of the hill, which was opened each morning to start the waterwheel turning for the mill. It was torn down in 1920. Railroad Avenue was a main thoroughfare for freight and visitors.

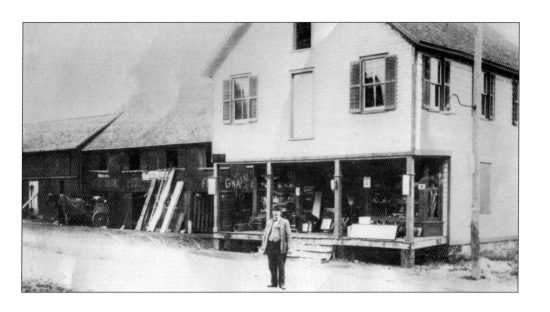

The Cromwell Store was one of many family businesses. Joshua T. Cromwell arrived in Highland Mills in 1835 and became a successful businessman who, with his family, owned and operated numerous enterprises before suffering financial problems in 1882. Shown above is George Cromwell, the youngest son, who worked for 20 years as the telegraph operator and stationmaster at the Highland Mills train station and then for four years as postmaster before devoting himself full-time to the store, selling general goods, hardware, coal, and lumber. With offices over the stream, the Cromwell Store occupied considerable space on the corner of Railroad Avenue and Hollis Street. A 1922 fire caused $20,000 worth of damage in the lumberyard, but the surrounding buildings were saved. Below is part of the abandoned building before its demolition in 1990.

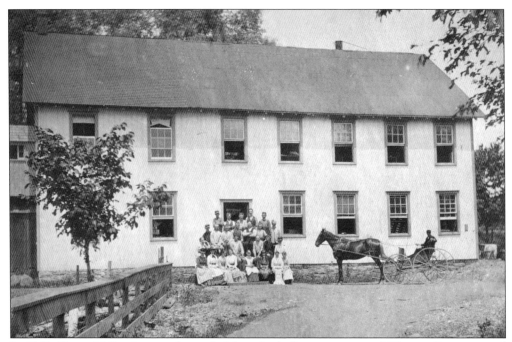

In 1840, Henry Hall, who was descended from Irish flax spinners, and Thomas Bates opened a fishing tackle business, manufacturing rods and reels, in Woodbury Falls. Bates died in 1868, and, due to conflicts with his heirs, the plant closed. Hall then moved to Highland Mills in 1870, operating first in a building near the Route 105 tannery before constructing his own 40,000-square-foot building on Railroad Avenue. The Hall Line Company employed men and women to make its respected silk fishing line. The long structure pictured below is typical of where workers "walked the line" to pull filaments away from the machines before twining and braiding them. As demand grew, locals were apprenticed until they became expert at twisting the line.

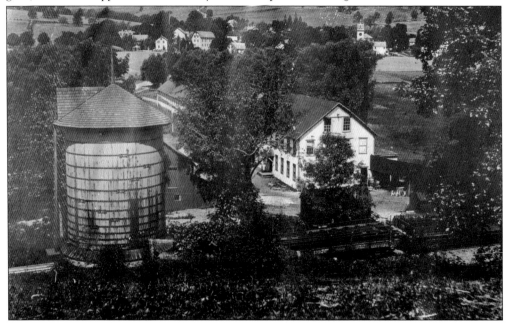

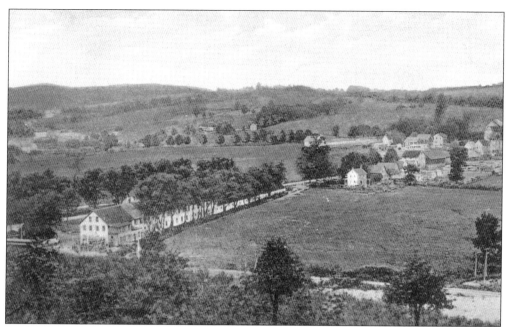

Declining business picked up when Hall Line secured World War II government contracts to supply survival lifeboat fishing kits, sutures, and parachute cords. The company expanded into some of Cromwell's buildings to meet wartime demands. Female employees sometimes put their names and addresses in the fishing kits in case a sailor used them and wanted to send a note.

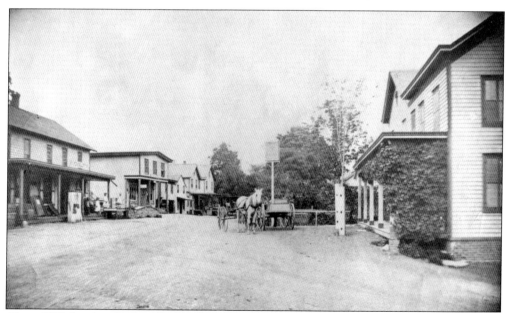

About 1880, heading back up Railroad Avenue, one passed the Highland Mills Hotel on the right corner before turning right onto Main Street, with its shops and private homes. On the opposite side of the road from the hotel, the Henry Cromwell general store, the Israel Owen meat market, and a notions store beckoned shoppers.

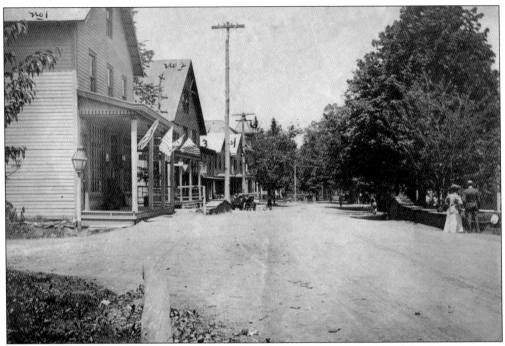

Here, around 1903, a car and utility poles are visible on Main Street. The Pembleton grocery store (near left) once housed a drugstore and a plumbing supply store. Next are the Cromwell Store, a meat market, James Lent's residence, Fitch's Drug Store, and the Highland Mills Improvement Building, which later became the town hall. To the left, past the first utility pole, is Monroe Road (now Route 105).

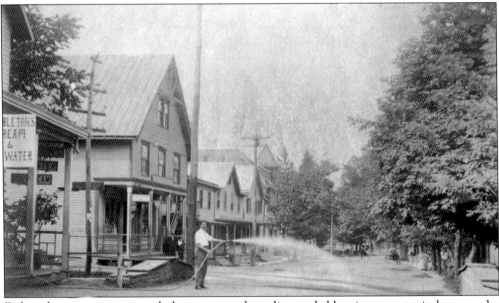

Before the streets were paved, dust generated on dirt roads blew into open windows, to the discomfort of residents and store owners alike. In this pre-1906 photograph, someone from the Pembleton store waters the road outside the entrance to keep the dust down.

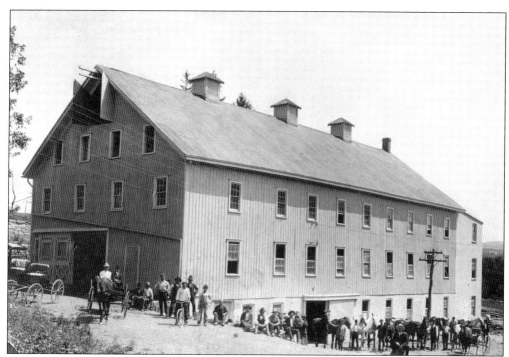

Known as the Townsend Tannery and then the Cromwell Tannery, this three-story building opened in the early 1800s, tanning different kinds of leather. Closed by the early 1900s, it became the Tannery & Hull livery business, stabling up to 40 horses. As cars became more popular, the building was later reused to store Tannery & Hull's road construction equipment. People recalled dancing and bicycling on the third floor. The senior center and the library occupy this site today.

Around 1870, Joshua Titus Cromwell's store sat near the intersection of Routes 32 and 105. A Quaker from Cornwall, Cromwell came to Highland Mills to operate the gristmill and tannery. His Highland Tannery produced high-quality leather that was then brought to Cornwall and shipped to New York City. In partnerships with his sons and his son-in-law Charles Townsend, Cromwell owned another tannery, the general store, and the Cromwell Lake House.

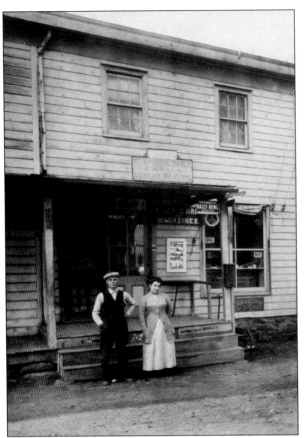

Ernest and Grace Jaeger stand in front of their Main Street store, directly across from Route 105 at the site of the former Murray's Irish House. The importance of visitors from New York City was apparent by their sale of New York City daily and Sunday newspapers, which continued after Louis Earl's nearby Soap Box store was demolished.

In this image taken around 1900, one can only speculate as to the use of the long pole held by the man on the far right, standing in front of the H.D. Ford Department Store. A projecting sign advertised gasoline for automobiles, which were beginning to appear in Woodbury. Ford's, like other businesses, moved around, buying or renting different buildings. This location was likely on the northwest corner of Routes 32 and 105.

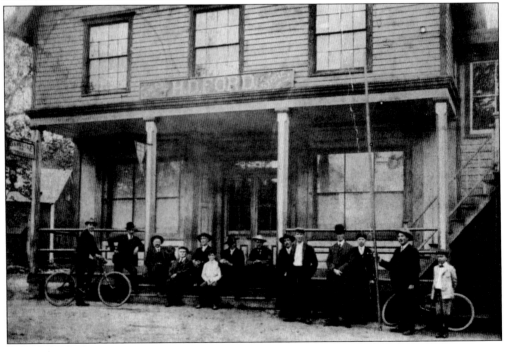

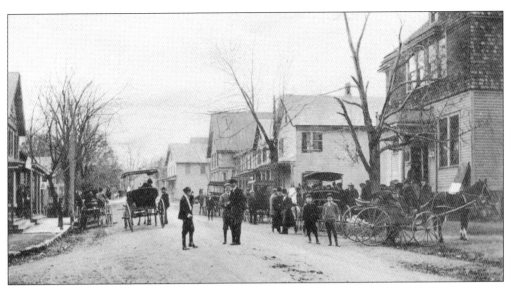

People congregate on Main Street in 1908. On the left is Elm Street, with the post office on the same side. In the right foreground is the Highland Mills Improvement Company, a privately owned gathering spot for meetings of fraternal organizations, band practices, movie shows, and school graduations. It was later purchased to become the town hall.

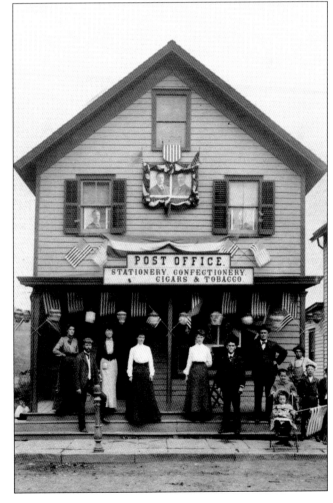

This building, once housing the post office, is still visible across from the town hall. Note the hitching post in front. The adults are, from left to right, Johanna Doe, Dr. W.S. Russell, Una Desconocida, Emma Hallock, Ada Hallock, James Lent Sr., and postmaster Henry Hallock. Life-sized images of Theodore Roosevelt and his running mate, Charles W. Fairbanks, were displayed on both floors for the 1904 presidential election.

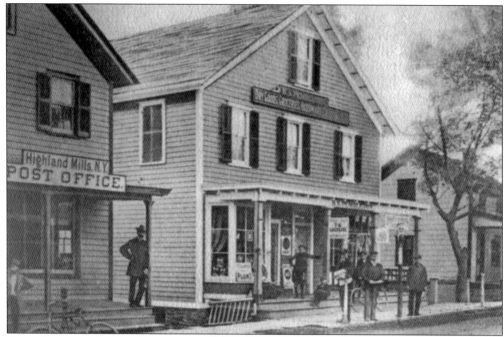

Over the years, the Pembleton name was associated with a number of businesses in various locations. Photographs in the early 1900s show a store near the intersection of Routes 32 and 105. This 1905 sketch places it next to the post office, on the other side of Route 32. It was hoped the attractive window displays would entice customers into the store to purchase dry goods, groceries, hardware, sundries, and other items.

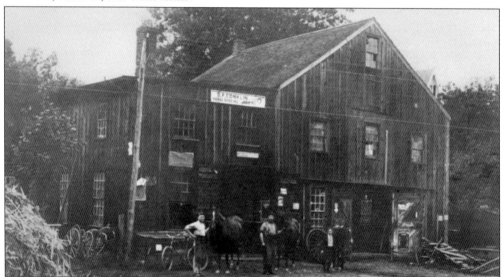

Reusing buildings, as opposed to tearing them down, was common practice in the 1800s. In 1859, Theodore Weygant, the brother of the owner of Weygant's Carriage Manufactory, purchased the first Highland Mills Methodist Church, which was being replaced, and moved it to the site of today's Café Fiesta and the post office to convert it to his wheelwright shop. In the early 1900s, members of the Highland Mills Band practiced upstairs. Around 1910, it became Daniel P. Conklin's blacksmith shop.

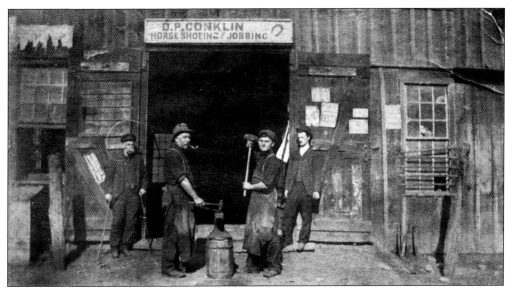

Daniel P. Conklin is seen here at the anvil, on the left, in front of his blacksmith shop. Under the previous owner, Theodore Weygant, it had been a wheelwright operation making wagons. The Adams brothers replaced this old building with their new, up-to-date garage. Later, the Grand Union occupied the site until it closed in the late 1970s.

Blacksmith Charles Eckert is seen here at his shop on Ridge Road. Besides shoeing horses, a major part of the blacksmith's business included various repairs of wagons, from making bolts to replacing structural parts such as crossbars and shafts, as well as making and repairing household utensils. These skills were much in demand in the 1800s and into the early 1900s due to the dependence on horses and wagons.

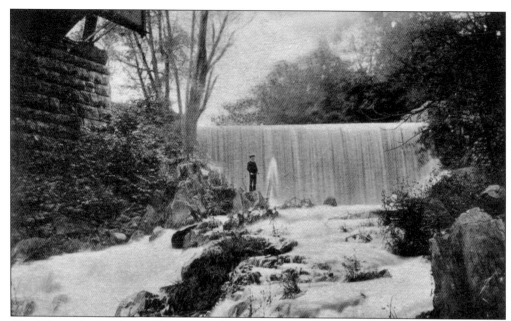

The falls, in the hamlet of Woodbury Falls, were located near the present-day railroad trestle in northern Woodbury. They were an important power source for early businesses, including a gristmill. A small iron furnace operated there briefly. Diaries speak of haze and soot from the numerous small charcoal pit operations. The original Hall Line Company was located below the falls.

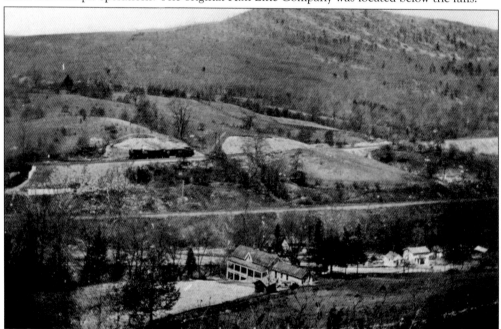

Looking out at Woodbury Falls, it is easy to see what enticed tourists to its numerous boardinghouses. Grocery receipts from the area around 1900 are from the William H. Stone store. The H.D. Ford Department Store also had a location here briefly. Oxen's blacksmith shop and Beake's Creamery are noted on maps. The falls disappeared when the lake was drained and the dam was removed for the widening of Route 32.

Six

HEALTH AND SCHOOLS

In 1889, residents of Central Valley could hear construction sounds in the steep hills above the hamlet. Little did they know that Dr. James Ferguson would open a revolutionary mental health treatment facility that was way ahead of its time. Dr. Ferguson, who called the facility Falkirk in the Ramapos, after his Scottish hometown, believed in the humane treatment of patients, a sharp contrast to the accepted norm of warehousing them, like prisoners, in insane or lunatic asylums. Nestled on approximately 150 acres, the buildings resembled residences on a country estate, with landscaped, parklike grounds, a few private cottages, and a greenhouse. An "open door policy" was practiced, whereby patients moved about the facility freely while receiving individual and intensive treatment. It later became a substance rehabilitation facility before closing in 1988.

Given the limitations of travel and distances between farms in the 1800s, it is understandable that many one- and two-room schoolhouses were scattered about Woodbury, from the mountain communities of Baileytown and Doodletown to the northern areas of Woodbury Falls. One of the earliest schools recorded in Central Valley dates from 1834. It was on the property of prominent resident Morgan Elmer, near the southeast corner of Rose Place. Sometime around 1862, a 22-foot-by-28-foot school house was built near the Route 32 and Smith Clove Road intersection. About the same time, a two-room wooden schoolhouse was built in Highland Mills.

Numerous respected private schools also existed, including the esteemed Estrada Palma Institute. Thevenet Hall operated the longest, closing its secondary school in 1971.

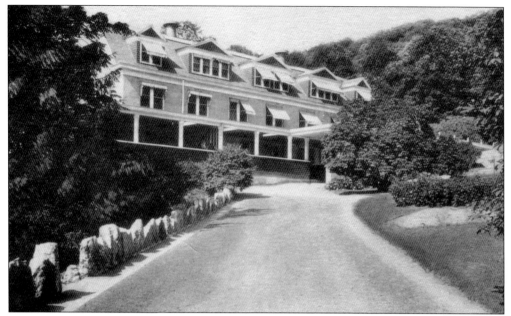

The largest of the main buildings at Falkirk in the Ramapos were the Falkirk, for men, and the Stanleigh, shown here, for women. A covered corridor linked them to the dining rooms. The buildings provided each patient with a private room, most of which had an adjoining bathroom. Private cottages with accommodations for a nurse were also available, as were cottages designed for up to three patients.

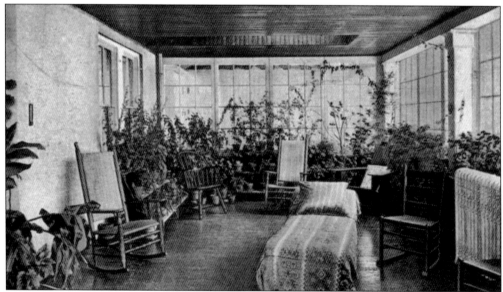

Falkirk emphasized serene surroundings and a homelike atmosphere, as seen in the Stanleigh's solarium. Patients were encouraged to enjoy outdoor porches, stroll around the beautiful grounds featuring gardens and trails, or play games of tennis or croquet. Libraries, recreation and game rooms, and living rooms were available. Rooms were provided for physiotherapy, massage, and occupational therapy. It was a revolutionary treatment approach.

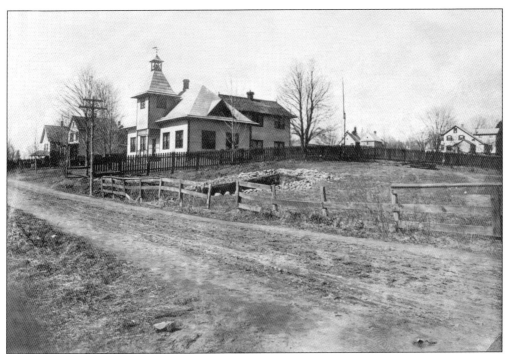

In splendid isolation, the original two-room Academy Avenue School, also called the Central Valley School House, was built in 1888 after numerous heated discussions. Construction cost $3,200. It sat on today's Valley Avenue, which was then little more than a dirt lane. In 1894 and 1896, residents voted to remodel and enlarge it to three rooms.

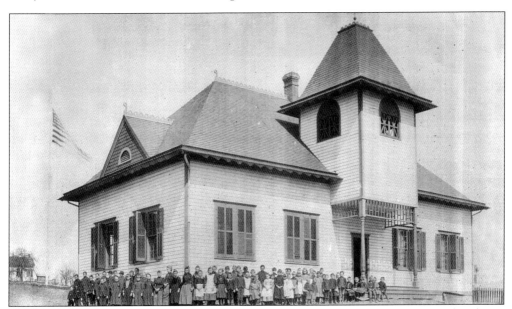

This photograph of the Academy Avenue School shows construction details, including a handsome second-story bell tower and double windows for light and ventilation. The crenellated wrought-iron roof cresting added elegance to the structure. The building, now a two-family residence, remains in its original location, although without the bell tower and trim.

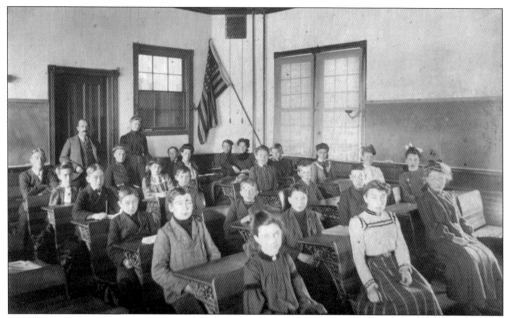

This early-1900s photograph shows the interior of the Academy Avenue School, with multiple grade levels in each classroom, which was the norm in those days. The first principal was Charles Rivenberg.

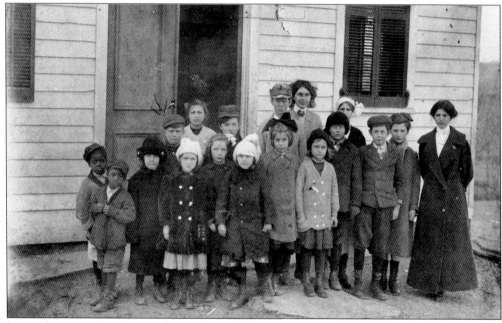

Located on Acres Road, the Bakertown School was built in 1872 on land donated by William and Ann Owens. Shown here is a 1912 class with teacher Miss Fleming. Although it was located in Monroe, Woodbury children living in that area walked to this school, including children with family names such as Stanfield, Hallock, and Hunter. It closed in 1936.

In 1862, this one-story, two-room, clapboard school in Highland Mills replaced the former one-room schoolhouse, which was moved to Ridge Road to become a private residence. Students ranged from elementary to high school age. Here, in 1889, this class gathers around teacher P.M. Mitchell. Soon after, a second story was added to the structure.

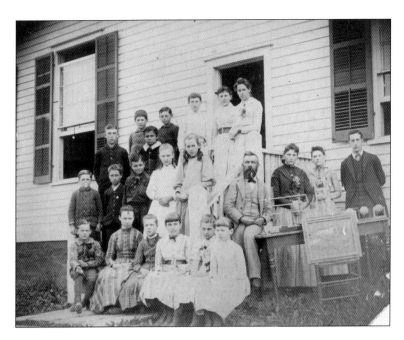

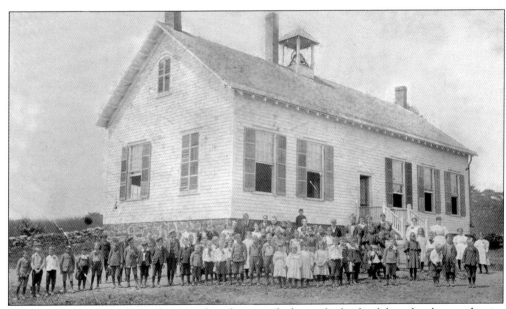

Believed to date from the mid-1890s, this photograph shows the back of the school, near the site of today's renovated Professional Building. The bell sat atop the building, ready to call students inside. The teachers were Margaret Morrison and Martha Mould. Many students had familiar names like Adams, Hallock, Florance, Thorne, and Miller.

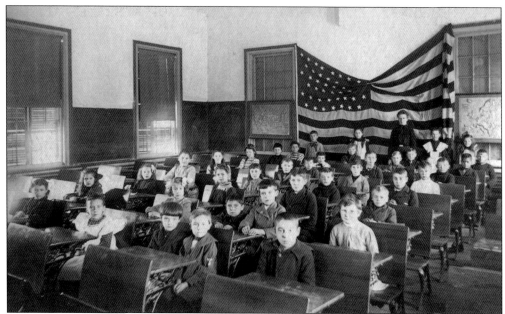

This classroom photograph was taken about 1904 in the wooden school in Highland Mills. Of particular note is teacher Martha Mould (back of classroom), a respected teacher in Woodbury schools for 37 years. Seated in the front row, second from the left is Emma McWhorter, whose dedication as an adult to recording Woodbury's families and history has allowed a remarkable glimpse into the town's past.

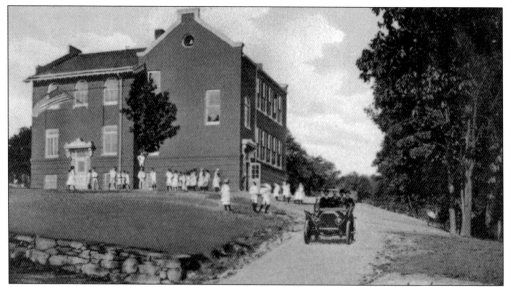

In 1907, it was proposed that the various Woodbury districts unite to create one larger district with a central school. Highland Mills unanimously voted no, and then approved $18,000 for the construction of a new brick schoolhouse near the earlier wooden building. By 1912, there were 105 students enrolled. District consolidation was finally approved in 1951, and the school closed in 1973.

The Woodbury Falls School, built around 1880, was located on Trout Brook Road, a short distance from the Route 32 intersection. This 1920–1921 photograph shows, from left to right, teacher Helen Pierce (who later married Percy Redner), Mildred Seaman, Lucile Earl, Ruth Grey, and Viola Lewis. In winter, the teacher would arrive early to fire up the potbellied stove.

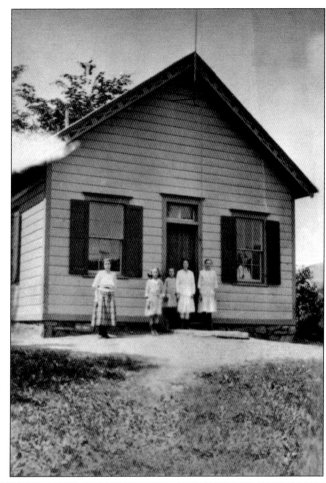

Located in the Twin Lakes area, this one-room schoolhouse served the mountain community of Baileytown and the children of the nearby area, many of whom were related. Children walked several miles up and down the mountain. For years, James W. Campbell served as a teacher and preacher. This was the only school many attended, since few wanted to walk or ride horseback the long distance to high school in Harriman.

The Doodletown school district was also in Woodbury. This was the second school, a wood-frame structure built in the late 1800s. Classes had previously been taught at the church. A one-room schoolhouse, this was used until a larger, two-room fieldstone school was constructed. By the mid-1960s, Doodletown was absorbed into the Palisades Interstate Park and disappeared.

In 1924, a new Central Valley School (now the Education Center) was completed. It contained 12 classrooms, with separate rooms for science, lunch, and a library, plus a large room for assemblies. Gym classes were held next door in the Central Valley firehouse, which is now a vacant store on the corner of Still Street. The school proudly graduated its first class—of two students—in 1928.

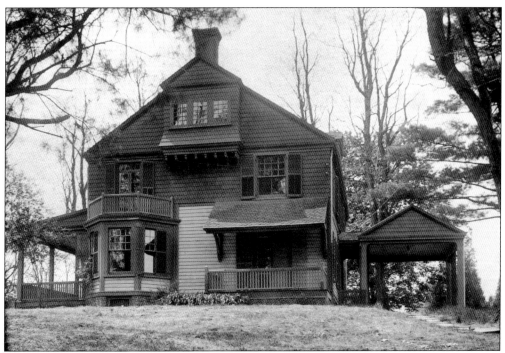

Demolished in 1968 for the construction of Smith Clove Elementary School, this handsome house belonged to civic-minded resident Richard Ficken, who created Limestone Park, donated land for the Central Valley Methodist Church, established an Estrada Palma Day fund, planted thousands of trees, held public office, served on numerous boards, and designed wide and well-graded sidewalks known as "Ficken sidewalks." This house was later the "principal's home" for the Woodward family.

Numerous private schools populated the area, including Stony Vale School, on Smith Clove Road. It was a day and boarding school built for and operated by Rebecca and Josephine Hallock. An 1876 report card shows a range of classes, including chemistry, geology, geometry, and philosophy, in addition to grammar, reading, rhetoric, and music. It later became a boardinghouse owned by Jesse Brown.

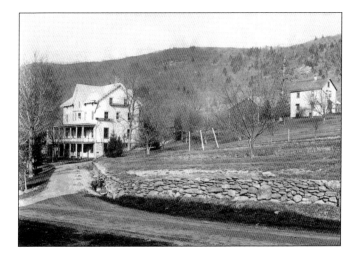

77

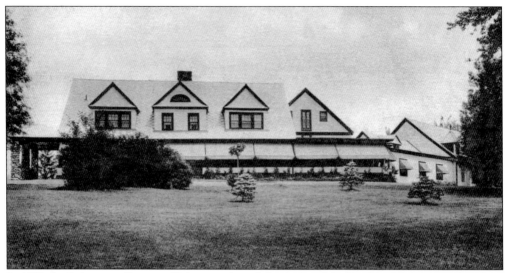

In 1911, the Religious of Jesus and Mary purchased the estate of the late Sen. Thomas C. Platt from his widow, intending to provide a rest home for nuns from New York and Canada and a training novitiate. The facility was forced to close the following fall because it was not self-sustaining and experienced water shortages. It reopened briefly during summers until the congregation's school was established.

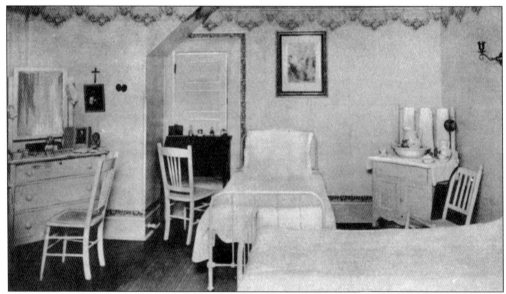

In September 1914, the Academy of Jesus and Mary officially opened as a girls' elementary and secondary school, with three boarders and one day student. Shown is a two-student bedroom; single rooms were also available. Girls could add personal touches to their rooms. A 1952 yearbook notes that girls could play radios in their rooms on weekends.

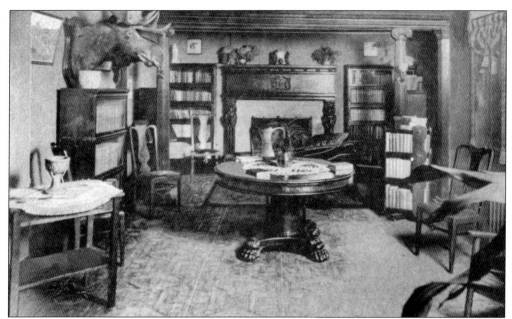

The library above and classroom below reflect the school's size and individual attention. Girls could enter at age four and graduate with high school diplomas. As the school's reputation grew, so did its enrollment, attracting not only local day students but also boarding students from New York City, Brooklyn, Long Island, and even Latin America. In 1926–1927, a chapel and auditorium were constructed and two floors were added to the annex. In 1930, the school changed its name to Thevenet Hall, after the society's founder. Attendance peaked in the 1960s, with 60–70 students. Declining enrollment forced the school's closure, and its last class graduated in 1971. The school became a retreat house, and the auditorium was converted to a Montessori school, which had 10 students its first year.

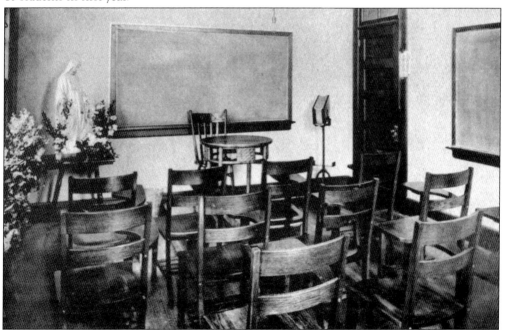

The arts were an important part of the curriculum, including piano lessons, choral singing, dramatic productions, and art classes. In 1916, Cornelia and Marie Etzel, related to the ACE Farm family, became boarding students. Cornelia, a professional artist, became a sister and taught art classes at the academy she had once attended. In 1920, the school received its New York State charter.

Students relaxed in the "snuggery," where games were played and music was enjoyed on the piano or the phonograph. Later, weekly movies were shown. A 1952 yearbook lists activities such as glee and drama clubs, the school newspaper, and sports, including softball, volleyball, and tennis. Outdoor recreation included tobogganing and ice-skating.

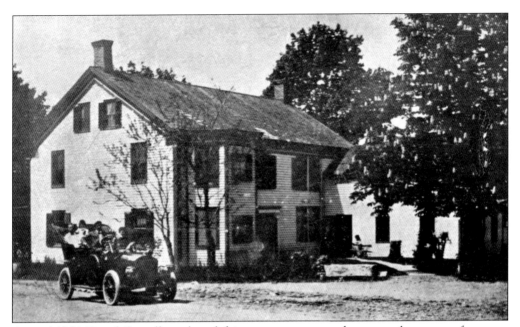

Around 1864, David Cornell purchased this tavern, a stagecoach stop on the corner of Route 32 and Dunderberg Road. He and his wife, Susan, both teachers, converted it into a coeducational boarding school that also accepted summer boarders. Revolutionary Cuban exile Tomas Estrada Palma and his family stayed at the school, where he became a teacher.

Enrollments at the Cornell School grew beyond what the original building could accommodate. In 1876, David Cornell purchased land across the street, on the corner of Estrada Road, and built Institute Hall. Besides being a school, the building was left open for public events, including dramatic productions, meetings, church services, and social gatherings. The Cornells supported and taught the arts at their school.

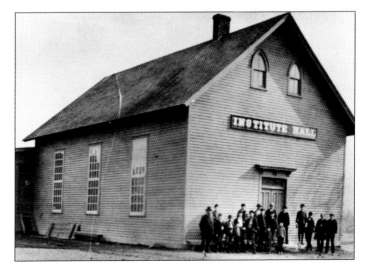

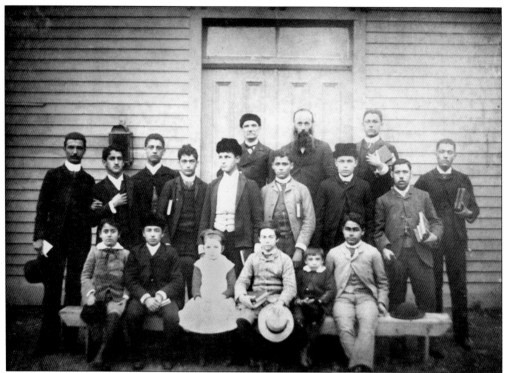

Shown in front of Institute Hall with their students in the late 1880s are Tomas Estrada Palma (top row, far left) and David Cornell (top row, second from left). With the addition of Estrada Palma to the staff, more Latin American students attended the school. The curriculum was a classical education, and students often went on to institutions of higher education.

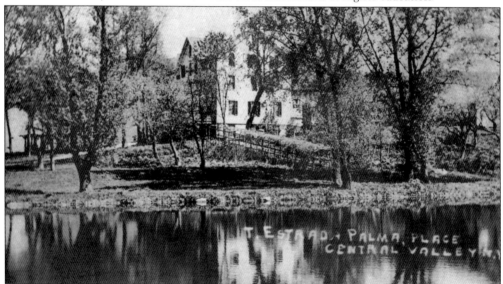

By 1890, Institute Hall had become too small. Tomas Estrada Palma purchased Locust Lawn, a three-story boardinghouse and pond on 19 acres, located on Estrada Road near the New York Thruway overpass. He headed the college preparatory school, called the Estrada Palma Institute. The Cornells moved there to live and teach. It closed a few years after Estrada Palma left in 1902.

Seven
FAMOUS PEOPLE

Woodbury was abuzz as February 11, 1942, approached. That was the date of the Red Cross benefit show, hosted and donated by the nation's foremost striptease artist, Gypsy Rose Lee, who not only performed but also brought in four major attractions for the show, held in the town hall. *Life* magazine sent photographers to cover the event to be featured in an upcoming issue. Approximately 300 people attended, bringing in over $500. Equally lively was Lee's auctioneering afterwards, with kisses as rewards for generous purchases. Why was this happening in Woodbury? Lee had purchased Witchwood Manor on Route 105, and was staying there with her mother and guests. In fact, her midnight New Year's Eve wedding to Alexander Kirkland, with a number of locals in attendance, was performed there.

Other celebrities were attracted to Woodbury. Songwriter and theater star George M. Cohan also purchased a summer home. Special arrangements were made for him, a few months before his death from cancer, to have a private preview in Monroe of *Yankee Doodle Dandy*, a movie about his life starring James Cagney. F.F. Proctor, the successful owner and operator of a major chain of vaudeville and movie theaters, enjoyed his country estate, which included a nine-hole golf course that is now part of Falkirk Golf Course. Woodbury even produced its own famous 1920s silent film and stage star, Glenn Hunter, born and raised in Highland Mills. His most famous play, made into a movie, was *Merton of the Movies*. He even costarred with Mary Astor. Famed American artist Winslow Homer stayed at Houghton Farm, where he created a series of paintings portraying farm life, featuring workers and animals. Schunnemunk Mountain is visible in some of these works.

Proximity to New York City, beautiful scenery, clean air, and available land at reasonable prices attracted many famous people. Politicians like Sen. Thomas C. Platt had summer homes here. Successful businessmen like wallpaper manufacturer Robert E. Thibault and attorney Charles E. Rushmore owned estates and were involved in the community to varying degrees. Railroad magnate E.H. Harriman purchased a 9,300-acre mountaintop and built the luxurious Arden House.

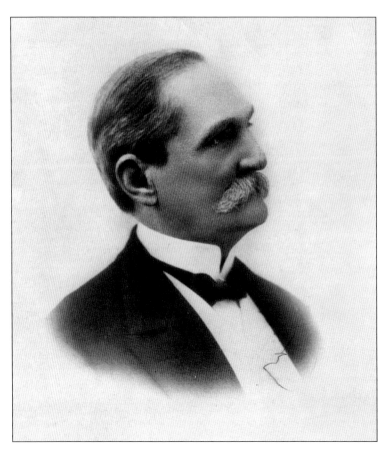

After imprisonment in Spain as a revolutionary, Tomas Estrada Palma eventually came to Central Valley to live and work at the Cornell School. With his family, he spent over 20 years here as a respected teacher. After Estrada Palma's May 1902 departure to become Cuba's first president, community leader and friend Richard Ficken established a special fund so local schools could annually celebrate May 20 as Estrada Palma Day.

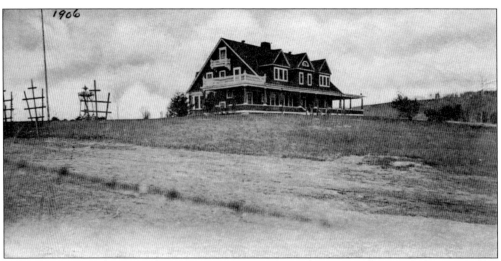

Before becoming Thevenet, this estate on Route 105 was the country home of Thomas Collier Platt, the powerful US senator from New York. Known as Tioga Lodge, it was sold after his death to the Religious of Jesus and Mary. It is claimed that strategy meetings with important politicians such as Pres. William McKinley and then vice president Theodore Roosevelt occurred here.

Charles E. Rushmore, at right, a successful New York City lawyer, his wife, and daughter lived much of their country lives in Highland Mills. Mount Rushmore was named to honor him because of his legal work for a mining company that was saved considerable money when Rushmore discovered the mines they intended to purchase there had been "salted" with minerals to make them appear valuable. The Rushmores built a Spanish Revival mansion on 1,500 acres that included a ballroom, a large guesthouse, a Ping-Pong house, stables, and a working farm with sizable gardens and a dairy. The ballroom was converted to house 3,000 recuperating World War I soldiers over a number of years. Below is the early interior of the Rushmore Memorial Library. The family contributed furnishings and books from their estate. The library was staffed by volunteers until 1962.

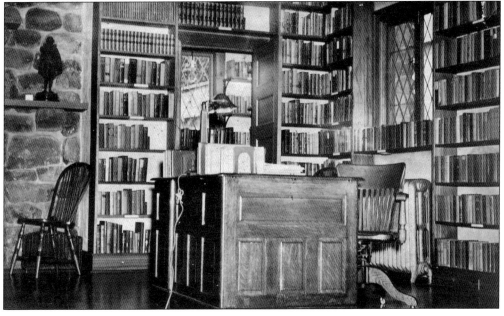

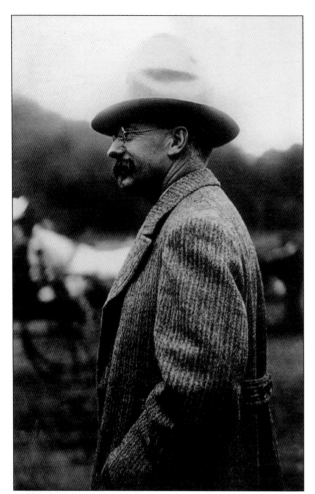

When the 9,300-acre Parrot Greenwood Iron Furnace property went up for auction in 1886, Edward H. Harriman was the highest bidder at $52,500. A horse and outdoor enthusiast, he and his wife, Mary, had prominent friends in nearby Tuxedo Park. Having worked at Parrot's one summer, he was partially motivated to purchase the property out of a desire to prevent lumbering interests from stripping the mountainside.

Tower Hill was selected for the construction of E.H. Harriman's 100,000-square-foot mansion, Arden House. When work began in 1903, workers, materials, and massive equipment were conveyed to the site over a slow land route until an incline railroad, running 2,782 feet in length, could be built. Additional infrastructure, such as a powerhouse, was needed to support this project.

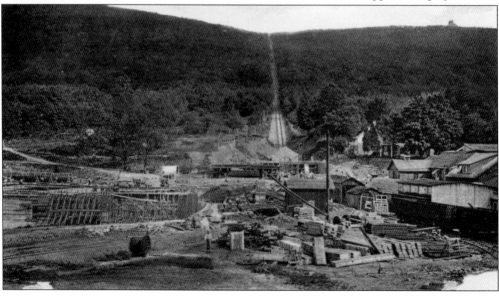

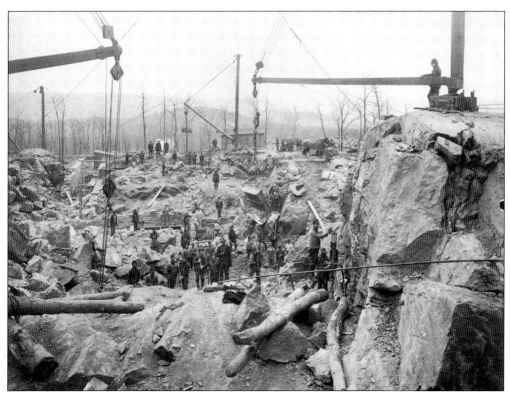

The mansion cornerstone was laid in 1906. Derricks, some 60 feet tall, were needed to move tons of rocks, earth, and building materials. Immigrants, mostly Italians, were brought in to work on the mansion, its infrastructure, and area roadways. In Woodbury, many of the workers lived in Hentown, which consisted of converted chicken coops on Estrada Road. Their descendants are now familiar local names, like Capriglione, DeVenuto, Travaglione, De Gregorio, Nazzarro, Perrone, and Vigliotti.

W. Averill Harriman, the governor of New York and an official serving four presidents, was one of E.H. Harriman's six children. He was barely five years old when his father purchased the property. Almost immediately, the family began spending weekends and summers there, staying at an existing house on Echo Lake right through the construction of the mansion. By 1908, approximately 350 workers were employed there.

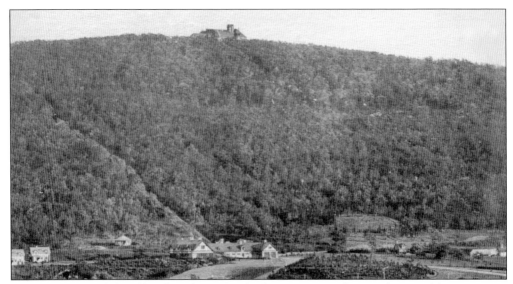

E.H. Harriman only lived briefly in his unfinished mansion, seen here at the top of the mountain, as he died in 1909. It was a personal and economic loss to the surrounding communities, since he had built and invested in numerous local enterprises, including the Arden Farm Dairy Company. Later, the family built the Bear Mountain Bridge. Mary Harriman remained at Arden House until shortly before her death in 1933.

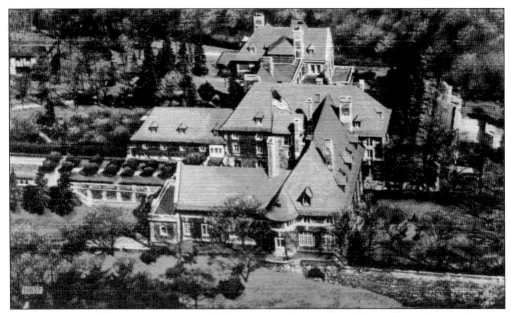

When completed, the mansion contained 96 rooms and 40 fireplaces. From 1943 to 1945, it became a Navy rehabilitation center. In 1950, it was donated to Columbia University for seminars and meetings of the American Assembly, a group created by Dwight Eisenhower. Most of the land, plus $1 million, was donated to create Harriman Park, the second-largest park in New York. The mansion was sold to an Asian nonprofit group in 2011.

Currently home to the Gatehouse Learning Center, this 1912 "puddin' stone" structure served as the picturesque entrance to Proctoria, the 1,140-acre estate of vaudeville and theater magnate F.F. Proctor. In front was the gatehouse, with the carriage house to the rear. Adjacent to the building, remnants of the roadway wind through the trees. In 2012, a reproduction of the building's original corner light was installed.

The many structures at Proctoria included four main residences, cottages, bungalows, five natural lakes, a boathouse, and farm buildings. Guests and business associates could partake of the "country life" while enjoying the large swimming pool, the nine-hole golf course, and other seasonal facilities. West Point had acquired much of the property by 1944 and razed most of the structures.

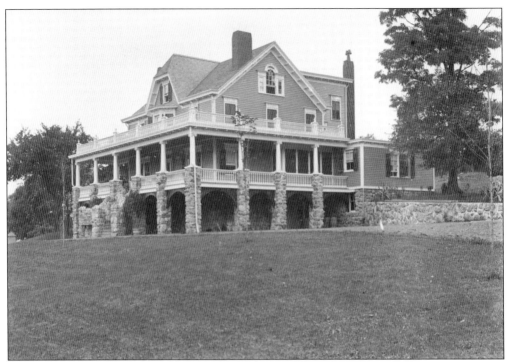

Across the street from today's golf course was the home of Dr. James Ferguson, the founder of Falkirk in the Ramapos. He also owned land where the golf course now sits, through which a road ran to his facility. The residence later became a clubhouse and then the Central Valley Inn, which offered a pool, open terrace dining, and French cuisine until closing in the 1970s.

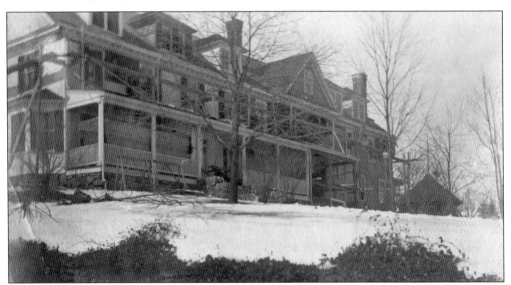

Known locally as the "Pink House," the Niemand home was the former residence of Robert E. Thibault, a leading wallpaper manufacturer with several wholesale and retail stores and factories. His was a "rags to riches" story. He enlarged the house, known as Fairfields, and also added a sizable children's playhouse. He contributed to numerous Woodbury organizations, donated a ball field, and served as one of the first Central Valley Bank directors.

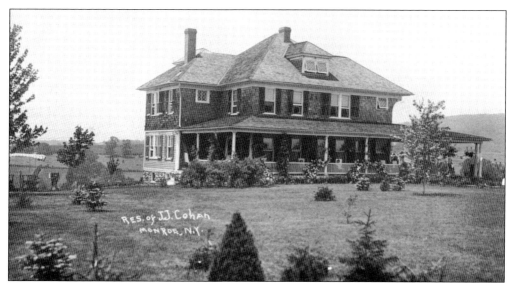

Around 1909, George M. Cohan purchased 40 acres straddling Woodbury and Monroe and built Sunnycroft, where his parents resided for the rest of their lives. Part of the famed Four Cohans, with his parents and sister, George often spent time there, composing in a cottage behind the main house. Known for writing patriotic songs "Over There" and "Grand Old Flag," he was also a lively dancer, playwright, and director.

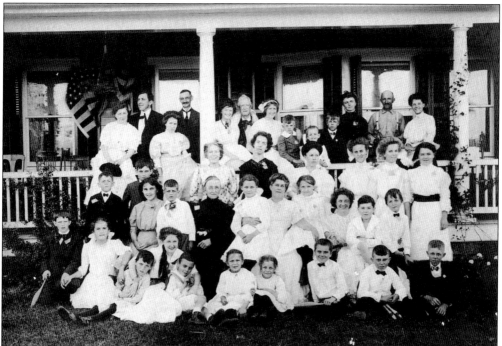

At this unidentified gathering, it is believed that George Cohan is in the back row, second from the left, and his father, Jerry, is sixth from the left. His mother may be in the second row from the bottom, sixth from the left. The family attended church and shopped in Monroe. After George's death, the estate became Sunnycroft Bungalow Colony until a number of fires destroyed many of the buildings, including the main house.

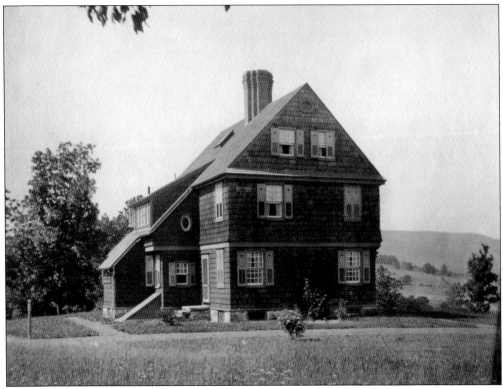

In 1934, striptease artist Gypsy Rose Lee purchased Witchwood Manor, a Colonial-style house, on Route 105. She had chickens there and installed a practice stage in the basement, complete with theater lights and her life-sized lobby-display cutouts. There were stories of private performances, by invitation, and of a nasty-tempered pet monkey, Rufus.

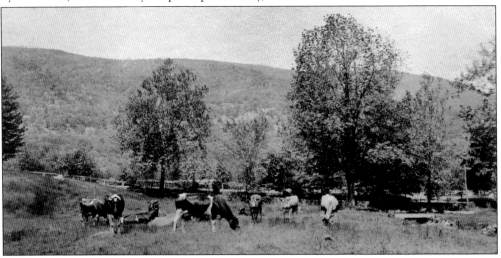

Houghton Farm was located on Route 32 towards Mountainville. Its pastoral beauty inspired painter Winslow Homer, who visited from 1877–1878 as a guest of Lawson Valentine, a boyhood friend and patron. There, Homer created a beautiful series of paintings illustrating farm life, including *Spring, 1878*, showing a girl crossing a stile over a fence, with Schunnemunk Mountain in the background.

Eight
COMMUNITY LIFE

As the 19th century was waning, changes were coming to Woodbury. While the tourist trade at upscale hotels and boardinghouses was still going strong, 10 years into the next century, hotel business would decline, affecting the local economy. Other changes brought on by technology were generally beneficial. In 1895, a waterworks company was formed, providing drinking water from Cromwell Lake. Telephone service began in 1900, when a small group of local businessmen formed the Highland Telephone Company. It struggled initially but proved successful, eventually relocating from a private home to the current town hall building. Around 1906, poles and wires were installed for electricity, replacing the less efficient and more dangerous kerosene lamps or gas jets. Streetlights, especially at intersections, were hailed as a vast improvement. By 1910, a total of 228 streetlights had been installed.

Residents enjoyed entertainment close to home. The Central Valley Mechanics Band, wearing colorfully decorated uniforms and feathered helmets, performed at the bandstand in a triangle formed at the intersection of Route 32 and Smith Clove Roads, or at Oak Clove Circle. Highland Mills boasted a fine band under spirited leader, composer, and cornet player Edson Miller, who performed at Sunnycroft events.

People cheered for local baseball teams against rivals. Community pride was vested in its bands and baseball and school teams. Parades with fire departments, floats, and bands highlighted community spirit. Sleigh-riding and ice-skating were popular winter activities, both inexpensive and nearby. A February 21, 1907, newspaper notes that 24 continuous days of local sleighing had been enjoyed that year.

Life was not exactly idyllic, however. Residents faced serious illnesses without the ability to determine causes or provide medicines to contain or cure outbreaks. In 1902, there were 12 cases of typhoid fever reported, and there was an epidemic 10 years later. Smallpox and diphtheria could decimate entire families. Woodbury also experienced losses during the 1918–1919 influenza pandemic. One motivation for a town water system was the belief that it would reduce typhoid outbreaks.

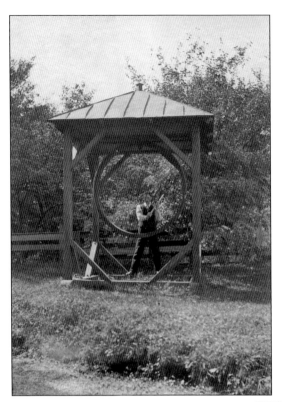

Before sirens and telephones, there was a need to alert community members about fires. The Central Valley fire alarm system was located on the west side of Route 32, at the top of Smith Clove Road. Here, around 1910, Jacob Besemer strikes the alarm, which carried a fair distance.

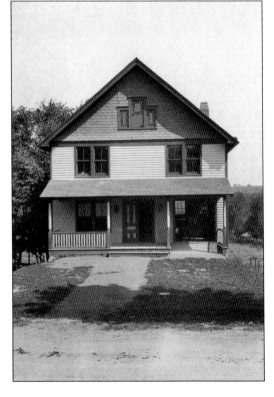

The first Central Valley firehouse sat behind Nearn's Opera House until Adelaide Grahlfs donated land on the corner of Still Street and Route 32 for the construction of this building in 1902, which cost approximately $2,500. A year later, the fire company was chartered by the state. This building burned down in 1909 or 1910.

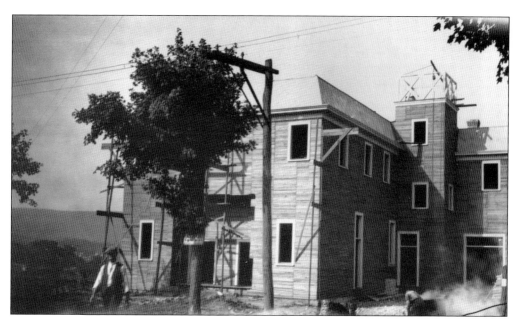

By 1914, another firehouse, with a siren tower, was built on the same site. Donations over the years included a hook and ladder truck from E.H. Harriman, ladders from Richard Ficken, and a hand-pulled hose cart from George Weiss. The basement jail, containing two steel cells, was made available to railroad-riding Depression-era men seeking work when it was not needed for criminals. Also a community center, it contained a bowling alley, pool tables, and a regulation basketball court, and it hosted Masonic meetings, plays, dances, and other events. The adjacent school used the building as a gym and for graduations. On movie nights, reels were transported between here and the town hall in Highland Mills. In 1957, when the fire company moved to Smith Clove Road, the building was sold for $17,000 to Walker Furniture Company.

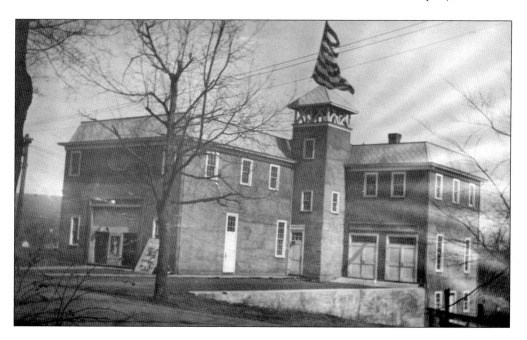

Community members volunteered to protect their communities. This 1913 photograph shows the Central Valley Fire Department. Formed in 1897, it was led by Dr. D.H. Sprague and Warren Gildersleeve and was known as the Athletic Association before organizing into the fire department a year later. In 1898, its equipment included 1,100 feet of hose.

It is believed that Carl Earl is seen here standing proudly beside this gleaming early fire truck with its shiny bell. The number of structure fires at the time was astounding. Before reliable water supplies and modern equipment, firefighting was dangerous and difficult. Fires at large structures, such as Hillcrest Hall, were especially challenging.

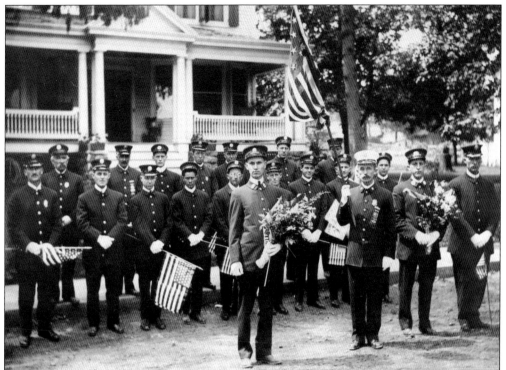

Highland Mills firemen line up in front of the funeral home. The community's residents met in 1899 about forming a fire company. A 1900 fire in the Knights of Pythias hall (later town hall) motivated them to move forward. A few years later, the fire company moved to what would later become town hall. It eventually purchased the property next door for a new firehouse completed in 1923.

From the early 1900s into the 1930s, local baseball, with the benefit of local newspaper coverage, was more popular than professional ball. This undated all-star flier lists eight Woodbury players, including Richard Haylock, who played for over 30 years, establishing many records. The new 1907 Taylor Field grandstand could seat 300 and stood until the 1950s. Nonlocals were occasionally hired to fill out the teams.

ALL STAR
Baseball Game

Benefit of the Y. M. C. A. of Orange County
BETWEEN

MONROE
Lou Smith, Manager
Winners of the Orange County Y. M. C. A. Baseball League—and

ALL STAR TEAM
Chester, Washingtonville, Woodbury, State School and Greenwood Lake

AT MONROE DIAMOND
Wednesday, August 29th, at 6 P. M.
If Rain, game will be played Thursday, August 30th at 6 P. M.
9 Inning Game
Umpires: Roy Green and Jack Diffily

ALL STARS
Frank Cromwell, Manager

G. Otterstedt, Chester, c.	J. Courter, Washingtonville, ss.
E. Clark, State School, c.	D. Arnold, Woodbury, ss.
B. Armour, Washingtonville, p.	S. Barnes, Washingtonville, 3rd.
D. Shearer, Washingtonville, p.	L. Traviglione, Woodbury, 3rd.
P. Woodward, Woodbury, p.	H. Dolson, Chester, 3rd.
T. Traviglione, Woodbury, p.	H. Beyers, State School, rf.
W. Scanlon, Washingtonville, 1st.	R. Haylock, Woodbury, rf.
R. Lent, Woodbury, 1st.	A. Decker, Chester, cf.
E. Sayer, Greenwood Lake, 1st.	E. Besemer, Woodbury, cf.
E. Kane, Chester, 2nd.	E. Waters, Greenwood Lake, lf.
C. Traviglione, Woodbury, 2nd.	W. Seaman, Washingtonville, lf.

Admission, 35c

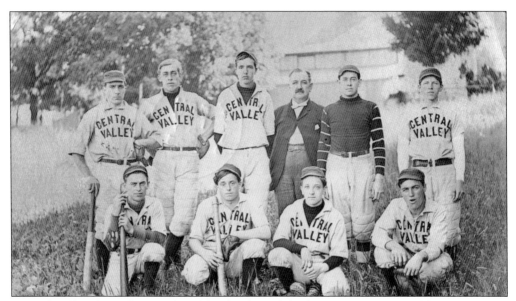

Central Valley, shown here, and Highland Mills each had two teams, supported by sponsors and businesses. The winning team played Monroe for the county title. The twilight league, which was mostly locals, played during the week. Saturday games were played after 3:30 p.m., since people worked half the day. Double- and triple-headers were held on Sundays. Weekend games included hired players. Opponents came from Newburgh, Poughkeepsie, and New Jersey.

The 1931 Central Valley High School basketball team was led by coach Alfred Mannheim, who also played on the local baseball team. Richard Haylock (first row, far left) was a multisport athlete. Since the school lacked a gym, the team played at the firehouse, which had the only regulation court in town. The court had a low ceiling, to the advantage of the home team.

Girls' teams also enjoyed popularity, as seen in this photograph of the Central Valley Grammar School basketball team with Coach Powell. Women's baseball games were also well attended, as reported in the newspapers, when the New York Bloomer Girls, who had fielded a team for 18 years, played in Central Valley. Local newspapers noted that men assisted as pitchers, catchers, and shortstops.

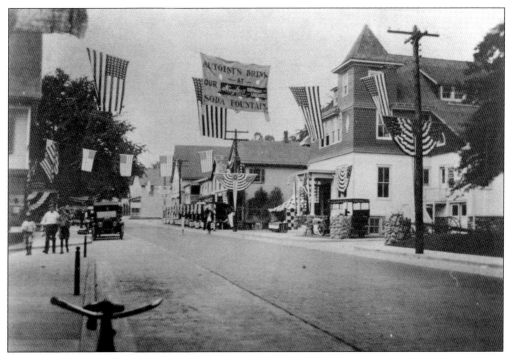

Around 1920, Highland Mills was decked out for a Fourth of July parade down its new asphalt-block Main Street. Note the future town hall with its tower, and a vehicle parked on the sidewalk. While a few cars are parked on the street, hitching posts are still visible. A huge Fourth of July celebration was held in 1919, welcoming home World War I veterans.

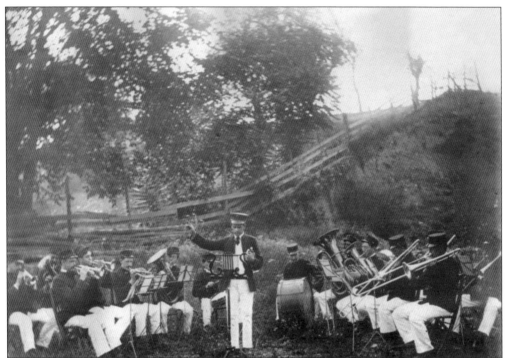

Bands were in demand and played wherever space was available, as demonstrated by this photograph of the Highland Mills Band. Besides parades and weekly bandstand performances, it played at baseball games and hotels and was hired for special events, like the 1907 Tuxedo Horse Show. Bands were so popular they were easily filled with homegrown musicians, while baseball teams often struggled to field enough players.

Decorated from top to bottom, this stone structure was the third Highland Mills bandstand, built in 1920 to replace the previous, wooden one. The first was on the corner of Elm Street and Route 32. The noise and speed of increasing automobile traffic along Route 32 may have contributed to the decline of concerts, which ceased around 1925.

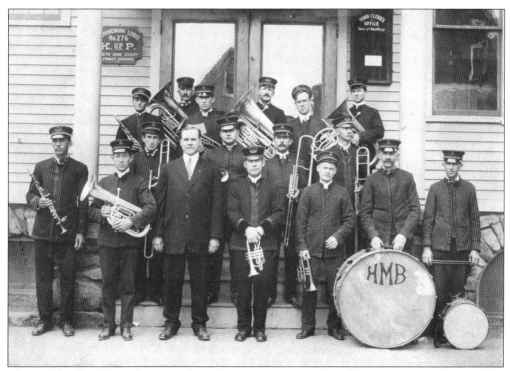

The Highland Mills Band presented outdoor concerts every Thursday evening. Members include, from left to right, (first row) Percy Pembleton, Nathaniel Lent, Clarence Turner, Edson Miller (leader), David Adams, Francis Earl, and Howard Weyant; (second row) Milton Pembleton, James Lent, Harry Eames, and Samuel Young; (third row) Roy Ansley, Edward Grover, Charles Carpenter, Edward Mosher, Mack Cromwell, and Frank Kershaw.

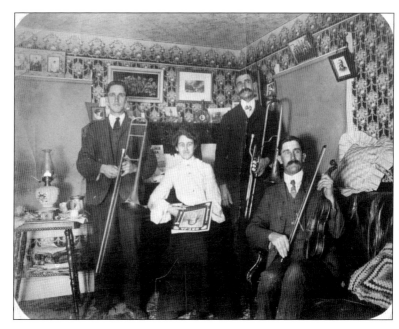

As seen in the enthusiasm for band participation and concerts, music was a very enjoyable community and family pastime. At their Ridge Road home, the Florance family had their own musical group, with Sadie on piano, Charles on violin, Harry on valve trombone, and Fred on slide trombone.

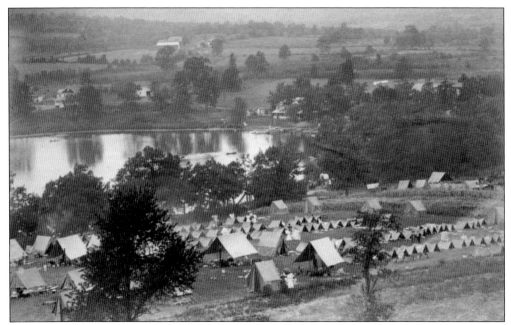

Not only hotel guests used Cromwell Lake, West Point encampments were also common. A 1938 news article records that the town's health officer, Dr. Frank Bullard, notified the cadets and the commandant that the swimming and washing of horses in the lake was forbidden since the lake provided the town's drinking water. Eventually, the town forbade boating, ice horse racing, and fishing at the lake.

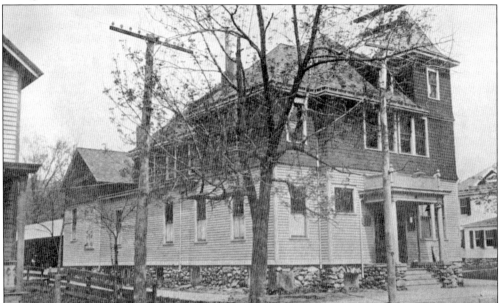

The previous building at this location, owned by the Knights of Pythias, burned down in 1900. The town rented an office for the town clerk and held elections there. Clerk Harry Cromwell was credited with saving the town records. This replacement was built by local businessmen, called the Highland Improvement Company, and rented for government offices and a jail. Square dancing, opera, and school graduations occurred on the main floor.

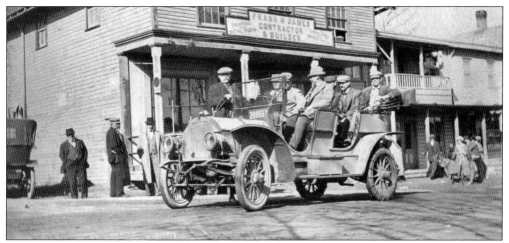

Riding an automobile along Route 32 on Election Day around 1912 was more eye-catching and comfortable than jostling along in a horse and buggy. Rear-tire chains were needed to navigate rutted roads following rain- or snowstorms. The early posted speed limit was eight miles per hour.

In 2012, the 1900-era Oak Clove iron entrance was being restored. David Cornell, with Tomas Estrada Palma, envisioned a college rising on their Summit Avenue property. Although it did not materialize, people referred to the area as the "college grounds." The tree-lined street, perhaps partially designed by Richard Ficken, became a restricted development featuring gracious homes with large yards. Originally, streetlights were forbidden.

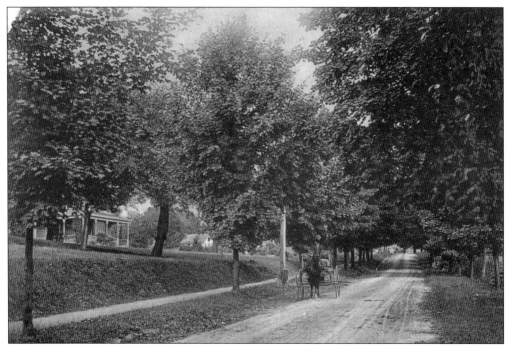

Whether along Smith Clove Road in Central Valley (above) or up to Schunnemunk Mountain (below), carriage roads were often rutted, with dust two to three inches deep on dry summer days. Before the early 1900s, each property owner was assessed one day of roadwork for each $400 of assessed valuation. Failure to comply resulted in a tax. Those without property paid a $1 tax or contributed a day of roadwork. Property owners were required to cut brush and grass on roads abutting their land before July 1. Hired workers were paid $1.25 for a 10-hour workday. In 1902, the state assumed maintenance of some the town's highways.

Nine

FAREWELL TO THE HORSE AND BUGGY

At the turn of the 20th century, the automobile was a novelty considered by many to be a "rich man's toy." Few roads were paved, and driving an automobile before Cadillac introduced the electric self-starter in 1912 required strength, agility, and stamina. Many a thumb was fractured in an effort to turn the crank to get the engine going.

In 1903, Dr. Worthington Russell of Highland Mills purchased one of the first cars in Woodbury. He had a wide choice of vehicles, since there were over 100 manufacturers at the time. It was reported that his automobile was faster than a horse and wagon, but local hills presented a challenge, sometimes requiring a horse to pull the car up the hill. Wealthier residents had both carriages and automobiles, perhaps as extra insurance if one proved unreliable. Carriages were still in use in 1906 when Nearn's stable supplied 33 vehicles for the wedding of Charles Rushmore's daughter.

Around this time, Highland Mills was the site of an endurance test. There must have been an audience at School Hill, on today's Route 32 where it climbs past the former school (now the Professional Building). Before regrading, this hill's steepness was the undoing of many participants. During that time, enough cars were driving through Woodbury that warnings were posted against fast driving. A 1907 newspaper clipping notes the increase in cars traveling through Central Valley from 190 for the same month the previous year to 346 that year. While numbers for subsequent years are unknown, increases must have been dramatic, since town minutes show road improvements were a main topic.

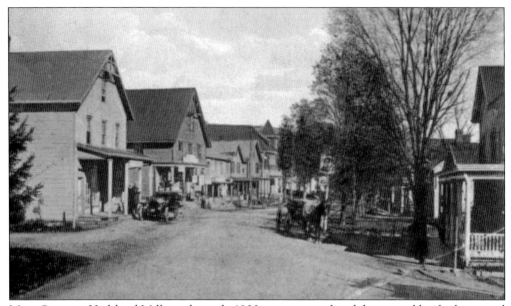

Main Street in Highland Mills in the early 1900s was unpaved and dominated by the horse and carriage, but automobiles, like the one parked in front of a store to the left, were beginning to appear, requiring better-designed and paved roads. In 1910, the town purchased oil to spread on roads near Route 32.

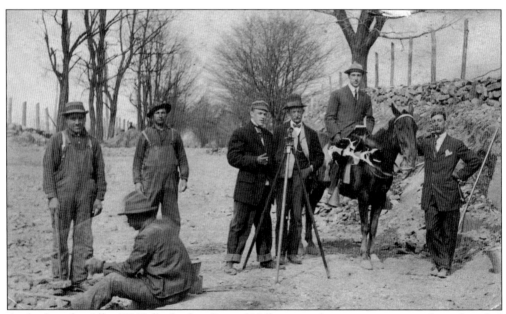

At the far right, Allen W. Hollenbeck, a Central Valley general contractor, poses with unidentified surveyors and a road crew, doing calculations on Route 32 in Upper Central Valley. There are bills from him well into the 1940s for sand and gravel deliveries. Around 1920, a bond was approved to help fund permanent improvements of Route 32, including through Woodbury.

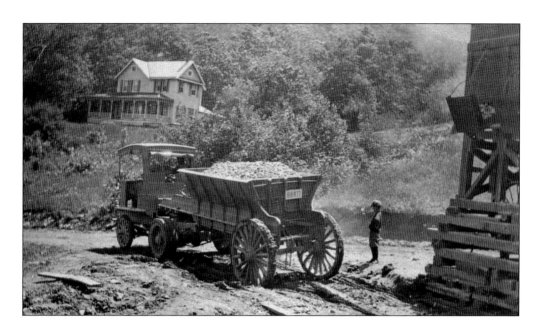

In 1917, construction on old Route 6 (now Estrada Road, and formerly Mountain Avenue or West Point Road) was progressing. Above, a young boy is fascinated watching the metal-wheeled equipment improving the original dirt carriage path to the upscale resorts. E.H. Harriman took an early interest in area roads, helping to form the Good Road Construction Company and subsidizing many improvements. Roadwork sometimes caused problems with utilities, such as in 1906 when construction between Highland Mills and Woodbury Falls partially uncovered water lines. The new Route 6 replaced the curvy and steep old Route 6.

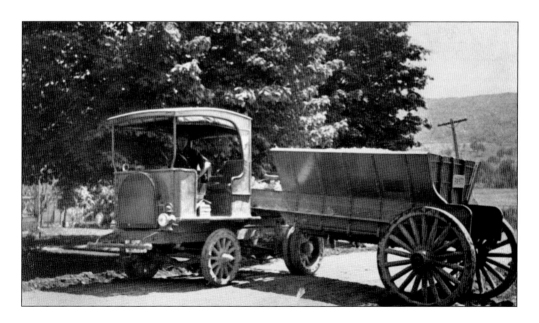

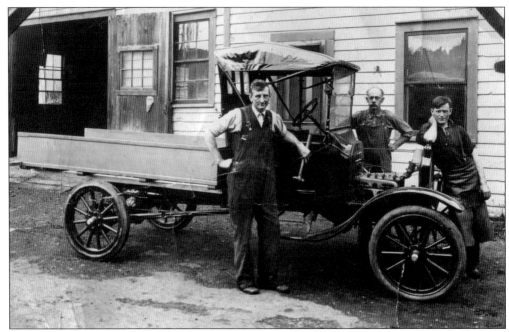

This early delivery truck had a top to keep the sun off one's head and a windshield. In 1906, drivers were cautioned about the state highway between Woodbury Falls and Orr's Mills. Due to a series of reversed curves, it was one of the most dangerous area roadways. Route 105 was the first local macadam road, and it was disliked because it was made too rounded, making it slippery when wet and hard on horses.

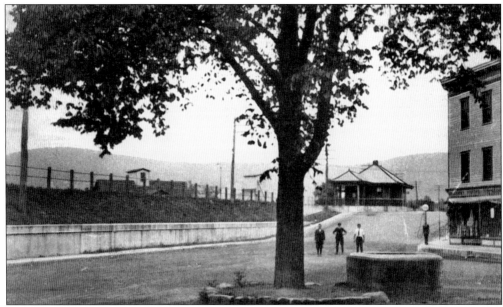

Three modes of transportation converge here in Lower Central Valley. Near the tree sits the water trough for horses and cattle, improved in 1907 to reduce the muddy mess from overflowing water. In the rear is the train station, and a gas pump for automobiles stands next to the Ford Department Store. The trough is still visible in early-1940s photographs.

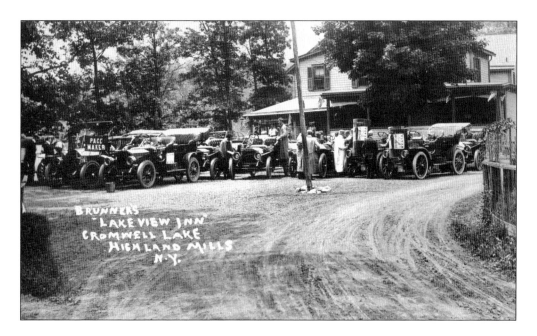

Brunner's Lake View Inn on Cromwell Lake was the site of this early-20th-century road rally and tour, sponsored by a motoring club. When cars were a novelty, these events were an opportunity for local citizens to inspect some of the hundreds of different automobile models being produced. Franklins, Locomobiles, Hupmobiles, Packards, and Studebakers, as well as Oldsmobiles, Chevrolets, and Cadillacs ranged behind a pace car traveling from town to town. Inclement weather would cancel the rally, since motoring in open cars was a fair-weather activity. Each automobile carried extra gasoline and a kit with screwdrivers, wrenches, and extra spark plugs. On unpaved roads, it was common to repair tires several times during a rally.

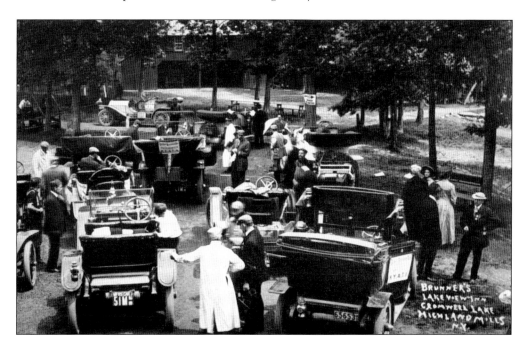

This group of men, including one with a stylish raccoon coat, gathers outside the new Central Valley firehouse and community center in 1917. Heavy coats were practical for riding in unheated, open-sided cars. Women wore heavy scarves over their hats due to the dusty roads. They were advised to smear cold cream on their faces to protect against wind.

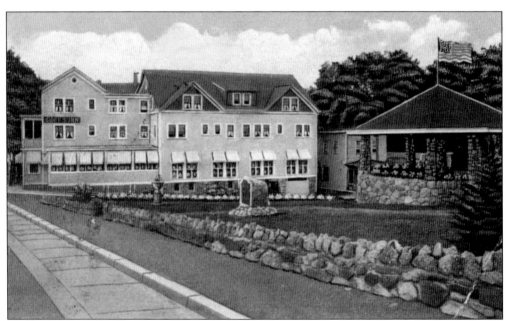

In 1923, Goff Inn replaced the Highland Mills Hotel on the corner of Park Avenue. More than triple in size, it covered the entire corner, offering sleeping accommodations and catering rooms for large gatherings. Meetings, elections, and social events occurred here. The Highland Mills Fire Company rented meeting rooms on the second floor and a hose room on the first.

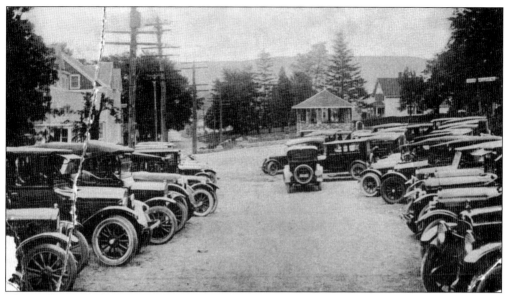

The Goff Inn, with its visible parking lot on Route 32 across from the bandstand, had an ideal location to attract the growing automobile trade. In the 1920s, business no longer depended exclusively on local patronage or long-term vacationers. The advent of the motorcar enabled transient visitors from far away to enjoy an afternoon meal or a one-night stopover on their way to more distant destinations.

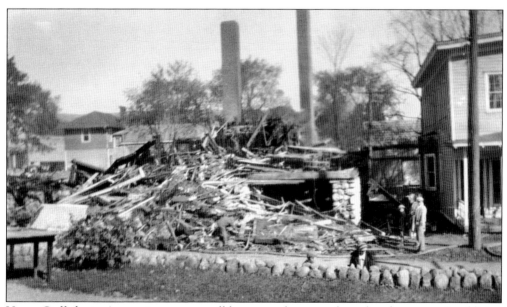

Henry Goff, the inn's proprietor, was a well-known and respected area hotel manager. In addition to his own establishment, he had managed Cromwell Lake House, Hillcrest Hall, and the Central Valley Inn. This successful operation came to a tragic end in 1928 following a party, when the inn burned to the ground. Firemen prevented its spread from wind-driven sparks to nearby houses.

Only main roads were somewhat improved, making driving on side streets, like Shuit Place, seen here, a jarring and dusty experience. The street was named for the Shuit family, who owned a house on the corner of Route 32 and Gregory Lane. Morgan Shuit was appointed by the governor to recruit men for the Civil War and held many offices, including town supervisor and state legislator.

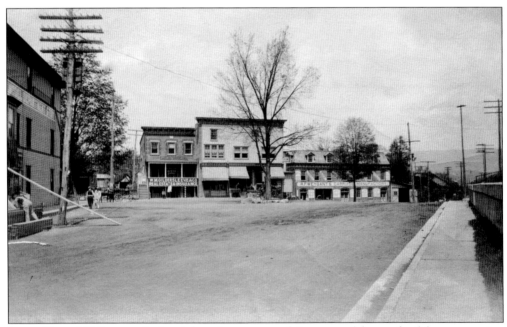

Lower Central Valley was the local shopping area, supplying most of the needs of the community. To the left was the Ford Department Store, housing a shoe shop as well as a butcher over the years. The more than 100-year-old elm tree by the water trough (later Perrone's Circle) had grown to over 100 feet before being cut down in 2013 due to disease.

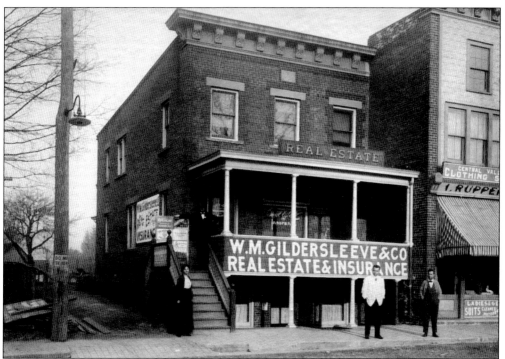

Warren M. Gildersleeve opened his real estate and insurance business in 1897. In 1909, he constructed this three-story building next to what had been the post office and the J.M. Barnes store, then occupied by Ruppert's Clothing Store. Gildersleeve, a civic-minded resident, is at the top of the stairs, and T.L. Rifenbury and I. Rupert stand on the sidewalk.

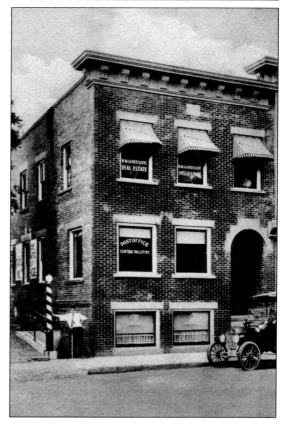

Gildersleeve's building was remodeled, and the open porch was replaced with more usable office space. It housed a barbershop on the ground floor, the post office on the second, and Gildersleeves's offices on the third. In 1923, Gildersleeve moved to his Route 32 location.

Two worlds—horse-and-wagon and automobile—meet at the former Weygant's Carriage Manufactory. By 1908, Robert Weygant's sons had transitioned into the automobile business, relocating to Route 32 and selling this building in 1920 to a silk manufacturer. In 1932, it became Henry Burgunder's garage, which sold the Locomobile. Burgunder's son "Bud," a former town supervisor, continued the business until 1968. Later, Brent McManus ran Cal's Auto Body here.

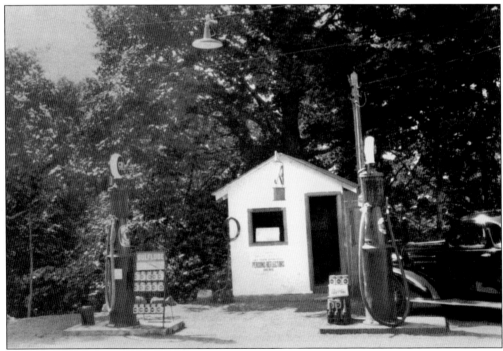

In 1935, Harold Schultz built his Imperial Motor Service station to attract customers on old Route 6 (now Estrada Road), the main roadway up and down the mountain into Central Valley. The business closed as traffic declined.

Ten

Changes Come to Woodbury

While the Erie Shortcut brought prosperity to Woodbury, by 1921, automobiles were reducing the railroad's profitability. That year, the Erie Railroad filed a petition to no longer employ agents at seven stations. While Woodbury was removed from the list and the decision was made that only two of the stations would be allowed to go to part-time staffing, the movement to close lines was underway. By 1936, the Shortcut was abandoned.

The once flourishing grand hotels began closing due to a decline in railroad travel and a loss of clientele as the automobile became more popular and affordable. Attempts were made to maintain these large buildings by updating them, as Mary Harriman did after purchasing the Mountain Top House. She also considered turning the main building into a "Fresh Air Home" for poor New York City residents. Dr. John Wellwood considered leasing it for a health resort. By 1913, the once beautiful mountain hotel closed permanently, and demolition began in December. Fire took others, like Hillcrest Hall and Goff Inn.

By the 1930s, camps and bungalows, with names like Evergreen, Holiday Hill, and Unser Camp, were replacing hotels and boardinghouses. George M. Cohan's Sunnycroft became a bungalow colony. These too would fade, however, as people desired different and more distant destinations.

In 1937, a former camp became the unique community of Raananah, formed by a group of New York City Jewish friends seeking a summer home that would be collectively owned, with no fences but with fresh air, providing an intellectual and cultural center for their families. It remains there today.

Businesses shifted owners and locations from Smith Clove Road and Railroad Avenue to Route 32, looking to attract the motoring public. Automobile sales and service stations replaced liveries and carriage shops. Housing developments replaced farmland. By the early 21st century, only two farms remained: ACE Farm and the Seaman Farm, with the latter converted to the smaller Palaia Winery.

In a spectacular fire discovered at 4:45 a.m. on September 6, 1941, three acres of buildings and merchandise of J.M. Barnes & Company, along with Redner's garage, were destroyed. The sleeping community was alerted by the frantic whistles of a passing train. Residents ran outside in nightclothes as paint cans exploded in the air like fireworks. The fire was so intense that utility poles ignited, although they were quickly extinguished by railroad employees. The only water to fight the inferno was pumped from Woodbury Creek. At left, the Central Valley fire truck was engulfed and destroyed while trapped firemen climbed a fence and jumped into the creek. The next day, people visited the site of the conflagration, walking around the ruins of a venerable and flourishing company. The estimated loss was $75,000. The business never fully recovered.

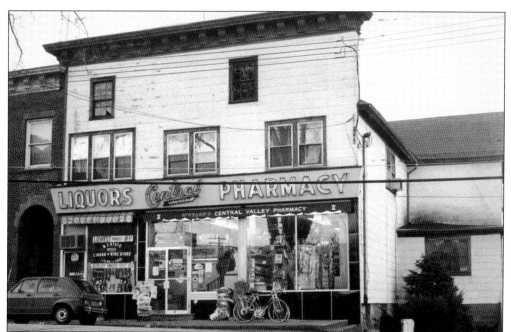

This building has housed many businesses since its days as the J.M. Barnes store and the post office. From its porch, Tomas Estrada Palma bid farewell as he departed for Cuba. In this photograph, a pharmacy and liquor store occupy the building. Singer's gift store later replaced the pharmacy. Today, Your Sport operates in this space.

Bob's Diner, owned by Bob and Fred Hintze, arrived on two trailers in 1936, locating across from the intersection of Smith Clove Road and Route 32. It closed around 1942 but was reopened by Joe Caruso and his father after the war. It was demolished in the early 1980s. A barn used as a riding academy and a large house for retired actors and teachers sat nearby. The house burned in 1956.

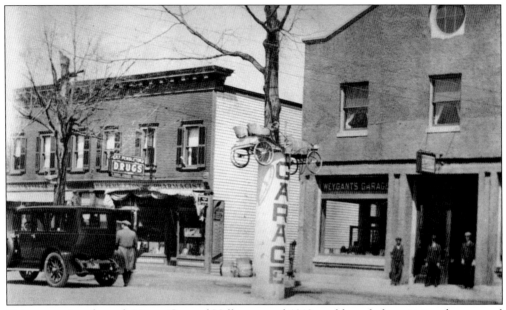

Drivers passing through Upper Central Valley around 1912 could not help noticing the unusual location of this automobile, a French Panhard, in front of Weygant's Garage. It was hoisted into the tree to grab attention. Business owner Russell Weygant stands in the doorway on the far right. The Pembleton drugstore was to the left. These buildings remain, but the stately trees lining Route 32 were cut long ago.

With the decline of the railroad and the increase of Route 32 automobile traffic, businesses adapted, moving to Upper Central Valley and changing owners. Weygant's Cadillac-Oldsmobile Garage became Lawson's Garage. Roadside pumps invited cars to pull up for gasoline. Next door, the Pembleton drugstore became Wright's drugstore. Traffic was light, allowing cars to park facing the curb without fear of being rear-ended.

This site, where Institute Hall once stood—followed by Nearn's Opera House and stable—became home to Lawson's Garage from 1912 to 1923, as the business sought to attract automobile customers along Route 32. When Lawson's moved north to Weygant's Garage, this building became Woolsey's Nash Motors, then Redner's garage, and, later, Berg's Auto.

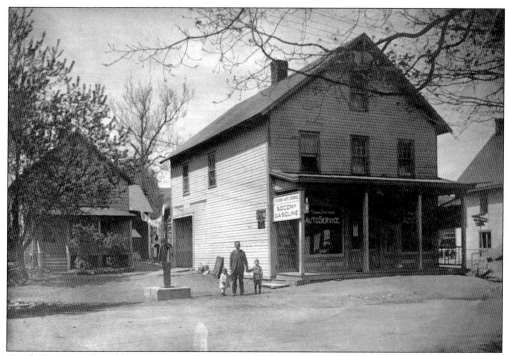

Frank Stevens, a local businessman, changed with the times. Standing with his children Marjorie and Frank in 1920 next to his Socony gasoline pump, he ran a Highland Mills taxi service for years, replacing horse-drawn carriages with automobiles. An addition to his house accommodated the town's first school bus. He also opened a restaurant in the house, which burned down years later.

Around 1950, a liquor store sat on the corner of Route 105, at the current site of Mario's Restaurant. Across the street, what is now McKenzie's gas station was a popular tavern. A decade or two earlier, a grocery store, a butcher shop, and a notions store were lined up, heading north on the same side of the street. The liquor store later became O'Brien's Restaurant, which burned down in 1961.

In 1951, Woodbury's entire police force was its first full-time officer, Robert Weyant, and its first police car, a 1950 Chevrolet. In 1963, the police department was officially formed, with William Bailey, a Baileytown descendant, as its first chief. Eight years later, the force increased to six full-time and three part-time officers. In 1989, the Niemand family donated land for today's police station.

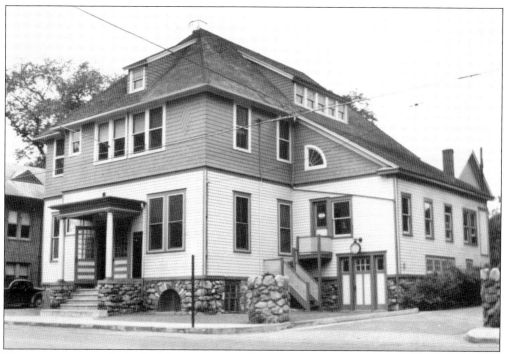

The town purchased this building, minus its Victorian tower, from the Highland Telephone Company for $6,000. Officially known as town hall, the building had the constable's office on the ground floor, in today's Parks office, and the jail in what is now the town clerk's office. The third floor, containing the telephone switchboard, is no longer usable.

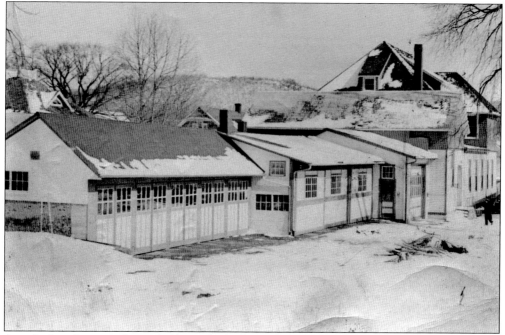

Attached to the rear of town hall was the highway department garage, previously horse stables. A 1989 fire destroyed the garage, damaging some equipment but sparing the main building.

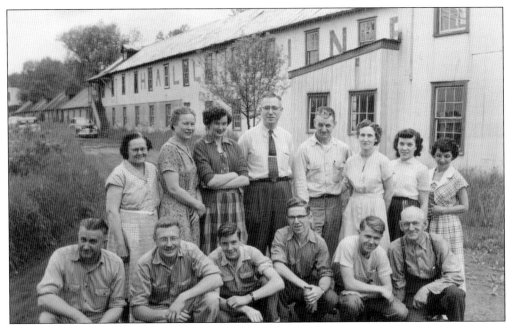

Employees pose in 1953 in front of the Hall Line Company. Pictured from left to right are (first row) Albert Benjamin, Joe Burrows, unidentified, Rodney Doyle, unidentified, and Ray Earl; (second row) Beulah Earl, Onni Ashton, Nancy Peterson, Alfred Paas (company president), Jerome Stanfield, Ruth Gray, Liz McDough, and Jeanie Nazzaro Blanche. Manufacturing stopped here in 1965.

This building has seen many owners over the years, but its predominant use was as a pharmacy. Built in the early 1900s by Elbert Fitch, this was once called the Old Elm Tree Pharmacy, because of the large elm tree nearby. Walter Belding purchased the pharmacy in 1922 and sold it to Kenneth Gray in 1953. It is now beautifully decorated as Flowers By David Anthony.

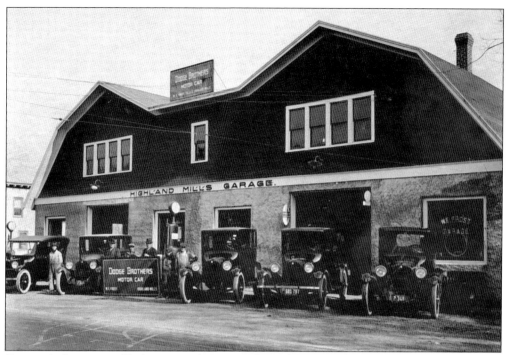

One might be surprised by how many businesses formerly occupied this space, now known as Jay's Deli. These included a blacksmith shop, a milk terminal, a bank, a carpet company, a real estate office, a barbershop, and a pet store. When this photograph was taken, it was the Highland Mills Garage, also called the W.E. Frost Garage, which sold Dodge Brothers motorcars.

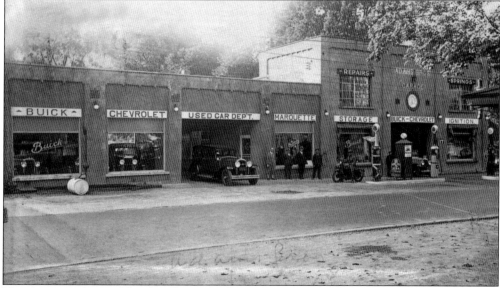

Now housing the Highland Mills Post Office and Café Fiesta, this site has witnessed many changes. In 1910, Weygant's Wheelwright Shop became Conklin's blacksmith shop. As automobiles displaced horse carriages, the Adams brothers replaced the former structure with their full-service gas station and Buick and Chevrolet dealership, catering to the needs of the motor age. They also sold fuel oil.

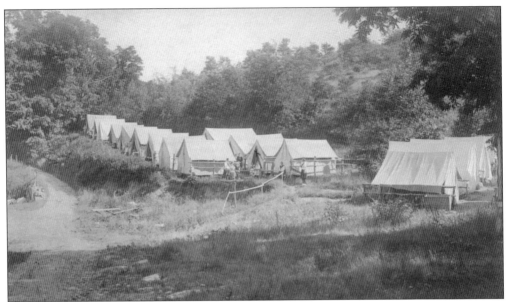

In 1917, the Young Christian Association of New York City opened a girls' camp near the former Summit Lake House. Although the hotel had closed in 1901, a group of investors purchased the main building and the surrounding property as a gentlemen's club. Members and guests used it until 1916, when it was sold to Mary Harriman. It was demolished about 1930.

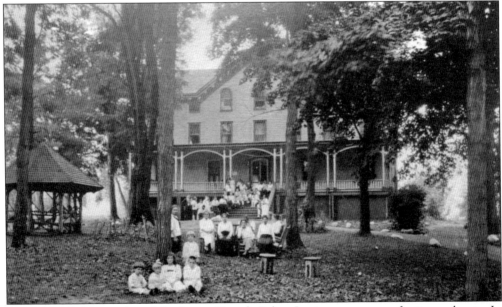

R.H. Macy & Co. purchased the former Estrada Palma Institute as a camp for its employees. In 1916, the children of Isidor and Ida Strauss (Isidor was a co-owner of Macy's), who died on the *Titanic*, gave it to Recreations Rooms and Settlement in New York City, a program that gave underprivileged mothers a two and a half week break while others entertained their children up to age seven. Fire destroyed the building in 1989.

After a 1921 fire destroyed Hillcrest Hall, some of the property was sold, becoming Camp Unser for adults and Camp Kindervelt for children. Following World War II, it greatly expanded, eventually totaling approximately 130 buildings, including cabins, bunkhouses, bungalows, and a motel, as well as dining and club facilities. At its summer peak, the population reached almost 1,000. It closed in 1972, and later became the Highland Lakes Estates residential development.

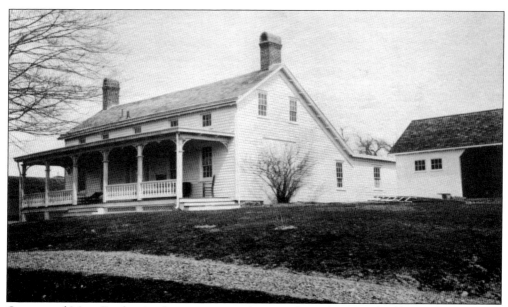

George and Mary Etzel arrived as summer residents in the early 1900s, building Adria, a stately home overlooking the farm. In 1917, their son Alfred and his wife, Elizabeth, began raising and selling goats, but her egg business, initially created to earn "pin money," replaced the less profitable goat enterprise. This is one of the houses on the 135-acre farm.

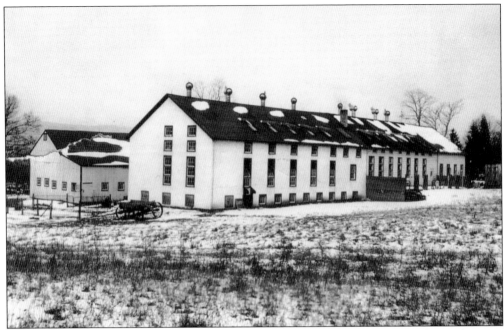

Alfred and Elizabeth Etzel focused on building their ACE Farm chicken and egg production business using the latest breeding and managing techniques. Alfred Charles Etzel's initials became their business name. His son Tyler and his wife, Lorraine, continued the business, which has since been passed on to their son Tyler Etzel Jr. and Michael Grindrod, another grandson of Alfred Etzel.

Since arriving in 1794, the Seamans farmed their land in Woodbury Falls, expanding operations to formally become Sweet Clover Farm in 1917. This 1940 photograph shows the Sweet Clover Farm Milk Bar shortly after it opened. Located on an undeveloped open stretch of Route 32 heading towards Mountainville, they hoped to attract summer automobile traffic to sell their fresh milk, produce, and ice cream.

James C. Seaman is ready for customers at the Sweet Clover Farm Milk Bar. The Seamans were progressive farmers, meticulously tracking each cow's production and health. Their cattle were regularly certified disease-free. Their farm business grew steadily despite the Depression, but it was seriously impacted by construction of the New York Thruway, which took 96 of their 284 acres. By the mid-1950s, the cows and milk routes were sold and the land was rented to other farmers.

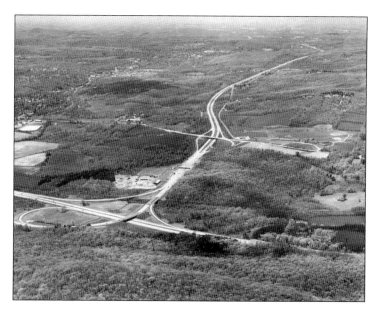

This is a mid-1960s aerial photograph of Central Valley. The New York Thruway runs across the bottom of the photograph, with the Harriman exchange leading off the Thruway between the intersections. Route 17 is straight ahead and to the left, and Route 32 is to the right. Today, the wooded area to the right of the exchange is the internationally visited Woodbury Common, where signs are posted in many languages.

Discover Thousands of Local History Books Featuring Millions of Vintage Images

Arcadia Publishing, the leading local history publisher in the United States, is committed to making history accessible and meaningful through publishing books that celebrate and preserve the heritage of America's people and places.

Find more books like this at
www.arcadiapublishing.com

Search for your hometown history, your old stomping grounds, and even your favorite sports team.

Consistent with our mission to preserve history on a local level, this book was printed in South Carolina on American-made paper and manufactured entirely in the United States. Products carrying the accredited Forest Stewardship Council (FSC) label are printed on 100 percent FSC-certified paper.